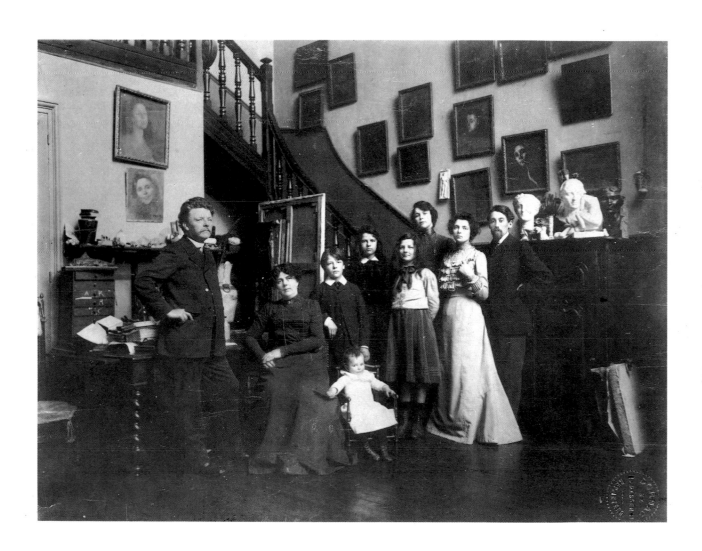

Eugène Carrière and his family

EUGÈNE
CARRIÈRE

Photographs researched and compiled
by Eileen Costello
Special thanks to Dominique Pichou
Edited by Jeanne Marie Wasilik

Designed by Tony Morgan, New York
Typeset in Versailles and Cochin by Trufont Typographers
Printed in Italy by La Cromolito, Milan
First printing 5,000 copies

ISBN: 1-878607-08-1
Library of Congress Catalog Card Number: 90-60854

EUGÈNE CARRIÈRE

The Symbol of Creation

by Robert James Bantens

with an introduction by Robert Rosenblum

KENT

Motherhood

c. 1880

Oil on canvas, 22 × 18¼ in.

Frick Collection, New York

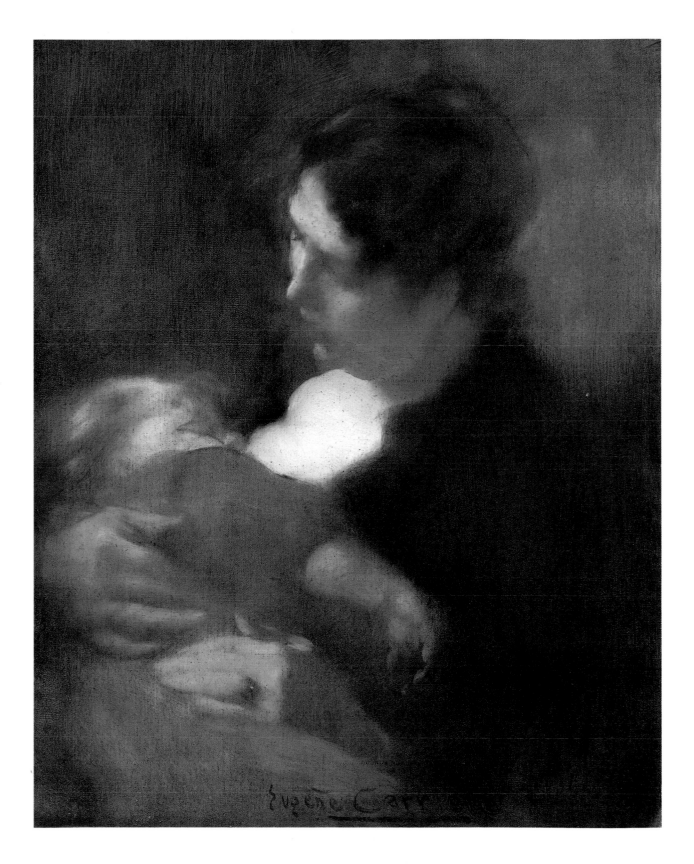

INTRODUCTION

ALTHOUGH AN ANCIENT CATECHISM ONCE TOLD US THAT THE FOUNDING FATHERS OF MODERN ART WERE, IN EFFECT, THE FOUR EVANGELISTS OF POST-IMPRESSIONISM—SEURAT, CÉZANNE, VAN GOGH, AND GAUGUIN—THINGS TODAY LOOK FAR MORE COMPLICATED. IN PARTICULAR, ANOTHER "ISM", SYMBOLISM, FAMILIAR ENOUGH IN STUDIES OF LITERATURE, HAS TURNED OUT TO BE MORE AND MORE USEFUL AS AN UMBRELLA TERM TO DESCRIBE THOSE STRANGE NEW CURRENTS THAT BEGAN TO EMERGE IN THE 1880S AND THAT WOULD REACH THEIR PEAK, ON BOTH SIDES OF THE ATLANTIC, BY THE TURN OF THE CENTURY. THE DRIFT WAS INWARD, A REJECTION OF THE EXTERNAL WORLD THAT COULD BE VERIFIED BY TOUCH OR SIGHT IN FAVOR OF EXPERIENCES THAT COULD BE FELT OR DREAMED IN A TERRAIN HOVERING BETWEEN TWILIGHT AND THE DEEPEST MYSTERIES OF SLEEP OR MYTH. EVEN IN AMERICA SUCH ARTISTS AS RYDER AND DEWING REVEALED THESE NEW INFLECTIONS OF PRIVATE FANTASY AND SILENT MEDITATION, AND IN EUROPE THIS ABOUT-FACE FROM THE PALPABLE REALITIES OF COURBET OR THE OPTICAL TRUTHS OF MONET COULD BE TRACED IN EVERY NATION. WHETHER IN MOSCOW OR PRAGUE, LONDON OR MILAN, BRUSSELS OR BARCELONA, ARTISTS WOULD SHUT THEIR EYES IN ORDER TO OPEN FLOODGATES OF FEELING AND IMAGINATION.

WITHIN THIS VAST INTERNATIONAL RANGE, PARISIAN ARTISTS PLAYED A CENTRAL ROLE, ALLYING THEIR VISION WITH SUCH FAMOUS LITERARY COUNTERPARTS AS VERLAINE AND MALLARMÉ, WHOSE SEARCH FOR A LANGUAGE OF EVOCATION RATHER THAN CLEAR STATEMENT, OF ELUSIVE MOODS RATHER THAN

OVERT EMOTIONS, THEY PARALLELED IN PICTORIAL TERMS. BUT THEIR MEANS FOR PRODUCING THESE SUBJECTIVE ENDS WERE SO VARIED AND EVEN CONTRADICTORY THAT TO PINPOINT A SYMBOLIST STYLE IS AS IMPOSSIBLE AS DEFINING THE CHARACTERISTIC STYLE OF ROMANTIC ART, WHOSE SCOPE COULD INCLUDE SUCH EXTREMES AS BLAKE'S WIRY LINE OR DELACROIX'S MOLTEN COLOR. SUCH DIVERSITY IS APPARENT WHEN THE WORK OF THE BEST-KNOWN FRENCH SYMBOLIST, GAUGUIN, IS CONSIDERED AS A COUNTERPART TO THE ART OF HIS FRIEND AND ALMOST EXACT CONTEMPORARY, EUGÈNE CARRIÈRE, WHOSE PAINTINGS STILL REMAIN CURIOUSLY LITTLE KNOWN IN THE UNITED STATES, DESPITE HIS REPRESENTATION IN MUSEUMS AS UNLIKE BUT AS UNIFORMLY DISTINGUISHED AS, SAY, THE MUSEUM OF MODERN ART, THE FRICK COLLECTION, AND THE METROPOLITAN MUSEUM OF ART.

FOR GAUGUIN AND HIS DISCIPLES, IT WAS THE EMBLEMATIC MAGIC OF CLEAR CONTOURS AND FLAT, UNMODULATED COLOR THAT MIGHT PROVIDE THE KEY TO UNLOCKING WHAT HE CALLED THE "MYSTERIOUS CENTERS OF THOUGHT." BUT FOR CARRIÈRE, AS FOR ANOTHER, BETTER-KNOWN FRENCH SYMBOLIST, REDON, TO DEFINE A FORM TOO PRECISELY WAS TO ROB IT OF ITS IMAGINATIVE RESONANCE AND NUANCED FEELING. MYSTERY, AS IN A SPIRITUALIST SÉANCE, COULD BEST BE CONJURED UP BY AN AMBIENCE OF HAZE, A MILIEU CLOSER TO REVERIE AND SLEEP, WHERE SMOKY PHANTOMS APPEAR AND VANISH AS IN A HALLUCINATION. YET CARRIÈRE AND GAUGUIN COULD BE SAID TO SHARE THE SAME GOALS OF PENETRATING EMOTIONS THAT LAY BENEATH THE FLESH AND OF

CREATING A PICTORIAL WORLD SO REMOTE FROM COMMONPLACE, EYES-OPEN EXPERIENCE THAT IT COULD EVEN ACCOMMODATE THE REPRESENTATION OF SUCH VENERABLE SPIRITUAL DRAMAS AS THE CRUCIFIXION. IT IS NO ACCIDENT THAT IN 1891 CARRIÈRE WAS ONE OF THE GROUP OF SYMBOLIST WRITERS, ARTISTS, AND CRITICS WHO OFFERED GAUGUIN A FAREWELL PARTY BEFORE HE SAILED OFF TO TAHITI, OR THAT IN THE SAME YEAR HE PAINTED A PORTRAIT OF HIS FLAMBOYANT FRIEND (FIG. 9) AND RECEIVED IN TURN ONE OF GAUGUIN'S SELF-PORTRAITS WITH A PERSONAL DEDICATION (FIG. 8). AND IT WAS CHARACTERISTIC, TOO, OF THIS FUSION OF PERSONAL FEELINGS WITH THE DOMAIN OF MORE UNIVERSAL MYSTERIES THAT, SOMETIME AFTER 1903, CARRIÈRE PAINTED A STRANGE ALLEGORY OF GRIEF (FIG. 25), A GHOSTLY PIETÀ IN WHICH A MOURNING WOMAN TENDERLY CRADLES THE HEAD OF A RED-BEARDED CHRIST WITH AN AQUILINE NOSE, A HEAD WHOSE IDENTITY MERGES WITH THE DISTINCTIVE FEATURES OF GAUGUIN HIMSELF, WHO HAD DIED IN WRETCHED HEALTH IN THE MARQUESAS ISLANDS IN 1903, ONLY THREE YEARS BEFORE CARRIÈRE FINALLY SUCCUMBED TO A THROAT CANCER THAT AGONIZED HIS LAST YEARS.

SUCH A COMPLEX EXCHANGE OF EMPATHY BETWEEN TWO HUMAN BEINGS, A COMMUNION OF KINDRED SPIRITS IN LIFE AND IN DEATH, WAS ALREADY DISCERNIBLE IN THE FIRST MATURE DECADE OF CARRIÈRE'S CAREER, THE 1880S. HIS *SICK CHILD* (FIG. 4), A LARGE AND AMBITIOUS CANVAS SHOWN AT THE SALON OF 1885, IS A PERFECT POINT OF DEPARTURE FOR THIS INWARD JOURNEY. IN MANY WAYS, IT IS A STOCK-IN-TRADE SENTIMENTAL GENRE SCENE IN WHICH NOT ONLY THE SICK

CHILD'S MOTHER AND SIBLINGS BUT EVEN THE FAMILY PET EXPRESS A HUSHED CONCERN ABOUT THE OMINOUS SHADOW OF ILLNESS THAT CASTS A PALL ON THE HOME. BUT IT IS EXACTLY THIS SHADOW THAT BEGINS TO GIVE CARRIÈRE'S PAINTING ITS PERSONAL FLAVOR, FOR HERE ALREADY A DARKENING TONE CLOUDS AND SOFTENS THE ORDINARY FACTS OF THIS SADDENED ROOM, RENDERING EVEN THE SIMPLE STILL LIFE OF BOWL, GLASS, AND DISH AS SOMETHING THAT ALMOST HOVERS OVER RATHER THAN RESTS UPON A MURKY BROWN TABLE.

SUCH PERVASIVE SHADOWS (WHOSE ORIGINS MAY BE PARTLY TRACED NOT ONLY TO CARRIÈRE'S TRAINING IN LITHOGRAPHY BUT ALSO TO THE INFLUENCE OF THE ESTABLISHMENT PAINTER JEAN-JACQUES HENNER, WHO SPECIALIZED IN SFUMATO) DISSOLVED EVEN MORE OF THE TANGIBLE WORLD IN LESS OFFICIAL, MORE INTIMATE PAINTINGS OF THE 1880S. AGAIN AND AGAIN, CARRIÈRE WOULD TAKE THE MOST SHOPWORN MOTIFS FROM NINETEENTH-CENTURY ART—A RURAL LANDSCAPE, A SERVANT SETTING A TABLE, CHILDREN READING, WOMEN WINDING WOOL, A PORTRAIT OF A MOTHER AND CHILD—AND RECREATE THEM AS MINOR MIRAGES, WHERE COMMONPLACE FACTS DISAPPEAR BEFORE OUR EYES. AND BY THE 1890S THIS ENVELOPING SHADOW, WHICH BLEEDS OUT ALL VESTIGES OF SENSUOUS COLOR, HAD BECOME SO ALL-ENGULFING THAT THE MANY FAMILY SCENES CARRIÈRE PAINTED TURNED INTO EMOTIONAL MELTING POTS RATHER THAN OFFICIAL RECORDS OF PARTICULAR PEOPLE AND PLACES. HERE, FEELINGS BETWEEN PARENTS AND SIBLINGS DISSOLVE THE OBSTACLES OF FLESH, MATTER, AND EVEN FURNITURE, MUCH AS THE PASSIONS IN THE SCULPTURE OF

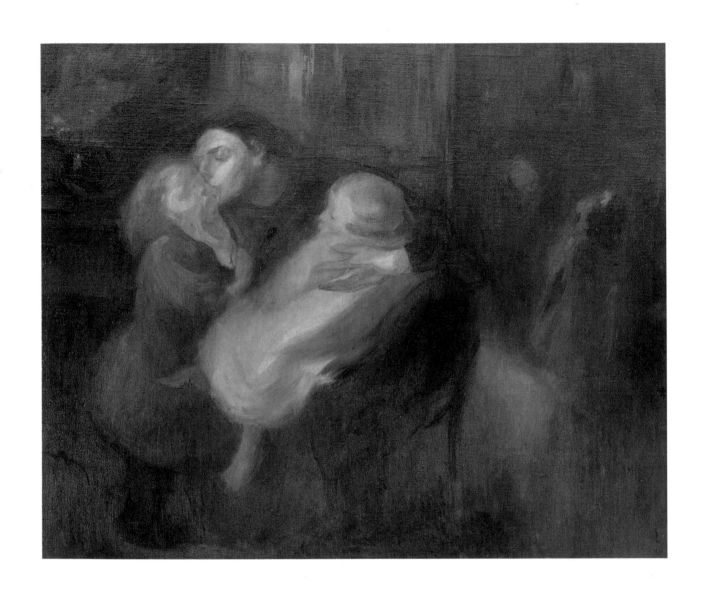

Maternité

c. 1892

Oil on canvas, 37¾ × 45¾ in.

Museum of Modern Art, New York

Given anonymously

CARRIÈRE'S GOOD FRIEND RODIN (WHO WOULD IN FACT IN 1904 ARRANGE A BANQUET TO HONOR THE ILL AND AGING PAINTER) SEEM TO FLOW DIRECTLY FROM ONE BODY TO ANOTHER, TRANSFORMING MARBLE AND BRONZE INTO AN ALMOST MOLTEN, FLUID MEDIUM. AND AS A FURTHER SCULPTURAL PARALLEL TO CARRIÈRE'S EMOTIVE FUSION OF FIGURES AND ATMOSPHERE, THERE IS THE WORK OF MEDARDO ROSSO, WHO IN THE 1880S AND 1890S EXPLORED A NEW MEDIUM OF WAX OVER PLASTER THAT, EVEN IN THREE PALPABLE DIMENSIONS, METAMORPHOSES COMMONPLACE SIGHTS—A CONCIERGE, A MOTHER AND CHILD, AN INFANT CHEWING BREAD—INTO AN EERIE KIND OF ECTOPLASM.

SUCH DEPTHS OF INEFFABLY TENDER INTERCHANGES WERE MOST OFTEN PLUMBED IN CARRIÈRE'S DEPICTIONS OF WOMEN AND CHILDREN, WITNESS THE MUSEUM OF MODERN ART'S *MATERNITÉ*, A TRIO THAT COULD ALSO MULTIPLY INTO A SEXTET, AS IN THE 1893 GROUP PORTRAIT OF HIS WIFE, SOPHIE, AND THEIR SON AND FOUR DAUGHTERS, ALL BORN WITHIN EIGHT YEARS. IN FRONT OF THESE DIMMING SPACES, WHERE ENTIRE FAMILIES EVAPORATE IN A VEILED AMBIENCE, ONE FINDS IT HARD NOT TO THINK OF DEGAS'S FAMOUS PUT-DOWN OF CARRIÈRE: "SOMEONE HAS BEEN SMOKING IN THE NURSERY." NEVERTHELESS, IF DEGAS, WHO ALWAYS CAST A COLD EYE, WAS LEFT UNPERSUADED BY THESE OVERT DISPLAYS OF FEELING, CARRIÈRE, IN HIS TURN, MAY HAVE LEARNED SOMETHING FROM DEGAS. FOR INSTANCE, HIS PORTRAIT OF THE WRITER ALPHONSE DAUDET WITH HIS DAUGHTER EDMÉE MAY RECALL, IN ITS ODD COMBINATION OF PHYSICAL PROXIMITY AND EMOTIONAL SEPARATENESS, THE FAMILY PORTRAITS OF DEGAS, MOST

PARTICULARLY THE BELLELLI FAMILY. YET THE OLDER MASTER'S CHILL IS TOTALLY ABSENT HERE, REPLACED BY A MURKY WARMTH THAT MERGES IN FEELING EVEN FIGURES WHO LOOK IN DIFFERENT DIRECTIONS. IT WAS FITTING THAT IN 1891 AT THE ONE-YEAR-OLD AND MORE LIBERAL OFFSHOOT OF THE OFFICIAL SALON, THE SOCIÉTÉ NATIONALE DES BEAUX-ARTS, CARRIÈRE EXHIBITED THE DAUDET PORTRAIT TOGETHER WITH THE PORTRAIT OF THE SYMBOLIST POET VERLAINE (FIG. 7), WHOSE SEARCH FOR FRAGILE NUANCES OF FEELING AND SENSATION WAS SO CLOSE TO HIS OWN. AND VERLAINE'S MOOD OF SAD ISOLATION—INTENSIFIED BY HIS ILL HEALTH AND TRIPS TO PARIS'S LOWEST DEPTHS—WAS CONSONANT WITH THE GATHERING CLOUDS THAT SHADOWED CARRIÈRE'S OWN HEALTH AND WORK. THE PAINTER, IN FACT, HAD IMMERSED HIMSELF IN VERLAINE'S POETRY IN ORDER TO COMPREHEND WHAT HE CALLED "THE TRAGIC SACRIFICE, EVEN CRUCIFIXION, MADE BY THIS MAN."

GIVEN SUCH A METAPHOR, IT IS NO SURPRISE THAT CARRIÈRE OFTEN ATTEMPTED CHRISTIAN SUBJECTS, NOT ONLY IN THE CONTEMPORARY TERMS OF A GIRL IN WHITE AT HER FIRST COMMUNION (FIG. 48) BUT IN SUCH TRADITIONAL THEMES AS CHRIST AND MARY MAGDALEN, THE NATIVITY (FIG. 70), AND, CLOSEST TO WHAT MUST HAVE BEEN HIS OWN, AND VERLAINE'S, MARTYRDOM, THE CRUCIFIXION ITSELF. PREDICTABLY, IN THIS LATTER TRAGEDY, WHICH WAS EXHIBITED IN 1897 AT THE "NATIONALE," CHRIST, LIKE THE CROSS ON WHICH HE IS SUSPENDED, SEEMS MORE HALLUCINATION THAN REALITY, A SPIRITUAL X RAY INSTEAD OF A FLESH-AND-BLOOD MARTYR. BUT THIS SEARCH FOR EVOCATIVE MYSTERY COULD EXTEND JUST AS EASILY FROM CHRIST'S MARTYRDOM TO A

PARISIAN INTERSECTION ON THE BOULEVARD DE CLICHY, WHERE THE ARTIST LIVED AT THE TURN OF THE CENTURY. HIS VIEW OF THIS BUSY THOROUGHFARE TURNS THE IMPRESSIONISTS INSIDE OUT, OBSERVING THEIR SUNLIT URBAN SCENES THROUGH AN ALMOST ILLEGIBLE DARKNESS, CREATING A SPOOKY NOCTURNE WHERE EVEN THE GLOW OF STREETLIGHTS SEEMS MORE TANGIBLE THAN THE PEDESTRIAN GHOSTS WHO HAVE LEFT THEIR BLUR UPON THE CITY. IN CARRIÈRE'S IMAGINATION, THE CITY OF LIGHT HAS BECOME A CITY OF SUCH MYSTERY THAT EDGAR ALLAN POE—A WRITER REVIVED BY THE SYMBOLIST GENERATION—MIGHT HAVE FELT AT HOME IN ITS SHADOWY MISTS.

EXTINGUISHING THE LIGHT OF THE SUN AND THE COLORS AND FORMS IT COULD ILLUMINATE, CARRIÈRE RETREATED INTO EVER MORE SOMBER AND MONOCHROMATIC MYSTERIES. ONE MIGHT INTERPRET THEM AS THE PRODUCT OF A PERSONAL AND OFTEN ANGUISHED TEMPERAMENT, WERE IT NOT FOR THE FACT THAT THEY ARE ALSO COMPLETELY AT ONE WITH THE MOOD AND THE LOOK OF SO MUCH BETTER-KNOWN ART FROM THE TURN OF THE CENTURY. INDEED, THEY EVEN CAST A DARK AND WORLD-WEARY GLIMMER UPON THE WORK OF A VERY YOUNG ARTIST WHO, IN THE YEARS JUST BEFORE CARRIÈRE'S DEATH IN 1906, ALSO SOUGHT SPIRIT RATHER THAN SUBSTANCE WITHIN A MELANCHOLY AND PERVASIVE MONOCHROME PALETTE: PABLO PICASSO.

ROBERT ROSENBLUM

45.

Le Théâtre de Belleville

1886—95

Oil on canvas, 88 × 196 in.

Musée Rodin, Paris (P7281)

The Symbol of Creation

by Robert James Bantens

De la vie

To ignore Eugène Carrière's art is to have an incomplete view of the esthetic climate of turn-of-the-century France. During his lifetime Carrière was no less admired and respected than his close friend Auguste Rodin, and he seems to have known, and been known by, nearly everyone who mattered in French artistic circles of the time — critics, collectors, and publishers as well as artists and writers. He was revered not only as an artist but as a kind and gentle man who ardently championed humanitarian causes. Rodin once told him, "You know how much you inspired me."[1] Paul Gauguin, who was notoriously stingy with his praise for other artists, called him "a great artist" whose "esteem is the great reward of my work."[2] Edward Steichen considered him "one of the greatest of modern French

painters."[3] And Isadora Duncan might have been speaking for many of her contemporaries when she recalled meeting Carrière in Paris in 1901:

He had the strongest spiritual presence I have ever felt. Wisdom and Light. A great tenderness for all streamed from him. All the beauty, the force, the miracle of his pictures were simply the direct expression of his sublime soul. When coming into his presence I felt as I imagine I would have felt had I met the Christ. I was filled with such awe. I wanted to fall on my knees, and would have done it, had not the timidity and reserve of my nature held me back.[4]

Eugène Carrière was born in 1849 in Gournay, Seine-et-Oise (today Seine-Saint-Denis), just east of Paris, the eighth child of Léon Carrière and Elisabeth-Margaret Wetzel.[5] When he was two the family moved to Strasbourg, not far from his mother's birthplace in Baden. Léon Carrière was an insurance salesman who struggled to support his wife and children, but he had come from a family of artists. Eugène's paternal grandfather, Antoine François Joseph Carrière, was a professor of drawing at the Lycée de Douai and his father's brother Alphonse was a portraitist and genre painter.[6] Both Eugène and his younger brother Ernest, who was born in 1858, began drawing and painting when they were very young, and at the age of twelve Eugène was enrolled at the Ecole Municipale de Dessin in Strasbourg to train for a career as a commercial lithographer. Carrière was a talented though not necessarily brilliant student, and in 1863 he was accepted as an apprentice in the lithography shop of Auguste Munch. Every year he won honors and prizes, and in 1867, when he was just eighteen, one of his drawings was selected for the exhibition in the Alsatian pavilion at the Exposition Universelle in Paris.[7]

In 1868, his apprenticeship completed, Carrière moved to Saint-Quentin to work for the printer-lithographer Moureau.[8] There he visited the Musée Lecuyer and was so impressed by the famous collection of pastel portraits by Quentin La Tour that he made many copies of them. (Years later he said that his own work at the time was "after La Tour".) But it was in 1869, when he made a brief trip to Paris and saw Peter Paul Rubens's paintings in the Louvre, that he decided definitely that he would become an artist.[9] He

gave up his job at Moureau and, despite his father's objections, left for Paris, where he was accepted into the studio of Alexandre Cabanel, a prominent academic painter at the Ecole des Beaux-Arts.

"I worked as a designer of all kinds of things, illustrations, etc. Thus I confronted the exigencies of life," Carrière later recalled about this period of his life.[10] Alfred Clochez, an industrial engraver from Moureau's shop in Saint-Quentin who had started his own business in Paris in 1869, provided him with commissions to design vignettes, menus, and the like.[11] He had only been in Paris a short time, however, when the Franco-Prussian War broke out.

In August 1870 Carrière was unable to reach Strasbourg, which was under seige by the Germans. He enlisted in the French army and joined the garrison of Neuf-Brisach. When the garrison surrendered he was taken prisoner and held at Dresden, where he remained until the peace treaty was signed in March 1871. Because he spoke German and was from the disputed territory of Alsace-Lorraine, the guards seem to have regarded him as a prodigal German rather than an enemy Frenchman, and he was allowed to leave the camp and wander about Dresden and its famous palaces and museums. He admired the many Rubens in the Dresden Museum, but he was especially taken with Raphael's *Sistine Madonna* (Fig. 13). When he died he still had the sepia-toned poster of the upper central portion of Raphael's painting that he had exchanged for several of his own sketches in Dresden more than thirty years before.[12] The poster was very likely the original inspiration for the many Maternités Carrière painted in his typical monochromatic brown palette.

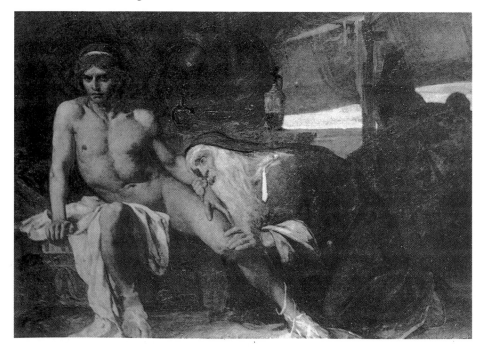

1.

Study for Priam Coming to Achilles to Reclaim the Body of Hector
1876
Oil on canvas, 8⅞ × 20⅞ in.
Ivan Loisseau Collection, Paris

In 1871, after a short visit to Strasbourg, Carrière returned to Paris and resumed his studies at the Ecole des Beaux-Arts. In 1872 and 1873 he worked in the studio of his friend Jules Chéret, whom he had met years before in Munch's lithography shop in Strasbourg and who was already well launched in a successful career as a lithographer and painter.[13] He also found work in the pottery studio of Théodore Deck, where his brother Ernest was apprenticed.[14] The problem of supporting himself and paying for his education was alleviated in 1874 when he received a grant from the département de Seine-et-Oise.[15]

In 1876 Carrière placed among the ten finalists in the Prix de Rome competition with *Priam Coming to Achilles to Reclaim the Body of Hector* (see Fig. 1), the most academic picture he ever painted. The same year he made his debut at the Salon de la Société des Artistes Français with *Portrait of the Artist's Mother* (Fig. 2). Neither that painting nor his entry in the 1877 Salon, *Portrait of a Young Girl*, was reviewed.[16] Frustrated, he left Cabanal's studio (which he later said had been a waste of time in any case), and soon after he married Sophie Desmonceaux in 1877, he and his bride moved to London. They spoke no English, however, and although Carrière found work with a commercial lithographer (his daughter kept several Christmas cards he designed for Marcus Ward and Co. that year), they lived in abject poverty.[17] Within six months they were back in Paris, where their first child, Elise, was born in 1878.

At the Salon of 1879 Carrière showed *The Young Mother*, the first of his many Maternités. It too was ignored, in part, Carrière thought, because of where it was hung. "No one sees my picture," he complained later.[18] He was no more successful with the paintings he exhibited at the Salons of 1880, 1882, and 1883, but in 1883 he was honored at last when *The Young Mother* was awarded a gold medal in Avignon and purchased by the state for 800 francs for the Musée Calvet. And the next year one of his two entries in the Salon, *Child with a Dog* (or *Two Friends*), received an honorable mention.[19]

The Carrières had a son, Eugène Léon, in 1881, and in 1882 their second daughter, Marguerite, was born. Still unable to earn enough with his painting to support his growing family, from 1880 to 1884 Carrière worked at the Sèvres porcelain factory, and it was there that he probably first met Rodin, who was at Sèvres off and on between July 1879 and the end of 1882.[20] Little is known of their relationship during the 1880s, but the few facts that are documented reveal the beginnings of what was to be a lifelong friendship based on mutual respect. In 1884, the year before he is reported to have told the art critic Jean Dolent that if he sold his portrait of Antonin Proust he would buy a painting by Carrière,[21] Rodin produced the first of a number of marble sculptures that seem to reflect Carrière's influence, a portrait of Luisa de Morla Vicuña that has the

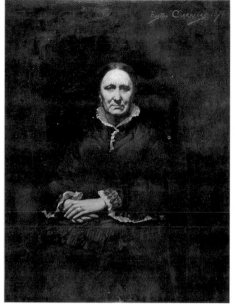

2.

Portrait of the Artist's Mother

1876

Oil on canvas, 52½ × 38⅞ in.

Musée de Strasbourg

melancholic, introspective air and slightly softened features of Carrière's female portraits of the time.[22] Rodin of course continued to create marbles like *Thought* of 1886, a clearly articulated figure released from a block of solid material to which it is attached by thin lines of webbing in the Michelangelesque tradition. But *Psyche* (Fig. 3), of the same year, is representative of a group of quite stylistically and emotively distinct marble figures that seem to flow from the shapeless, primal matter of the rough and undifferentiated block just as Carrière's poetic images coalesce from the dark atmosphere of his paintings. "Carrière is also a sculptor," Rodin once remarked. He may have seen in his friend's work, with its subtleties of value and figures neither fully conceived nor completely materialized, a logical extension of Michelangelo's esthetic of the incomplete.

By 1885 both artists and critics had begun to take notice of Carrière. His prize at the 1883 Salon, he realized later, had been far less important than his introduction that year to the critic Roger Marx, who favorably reviewed *Child with a Dog* in his piece on the Salon. Two years later, when Marx reviewed the Salon of 1885 in *Le Voltaire*, he had only praise for "Monsieur Carrière":

Only those who respond to an inner genius and who paint what they feel can create works of strength; witness M. Carrière. The love of nature that moves him to contemplate life allows him to see in children treasures that are invisible to indifferent eyes. [When] M. Carrière depicts the illness of the last born, the silence of pain hovers in the room the painter has filled with repose, [and] he has put in the sadness of his colors something of the terrible anguish of the mother.[23]

The painter Benjamin Constant persuaded his fellow Salon jurors to award Carrière's *The Sick Child* (Fig. 4) a second-place medal, and the state purchased it for 1800 francs for the Musée Montargis.[24] But with this good fortune also came sorrow, for late in 1885 Carrière's four-year-old son, Eugène Léon, died of diphtheria.

The state also purchased one of his 1886 Salon pieces, *The First Veil*, for 1200 francs.[25] His portrait of his friend Louis-Henri Devillez, the Belgian sculptor, won a medal at the Salon of 1887 but no prize money.[26] This was a period of even greater financial strain for Carrière, and he continued to work for commercial lithographers to earn a living. His daughter Nelly was born in 1886, followed by Jean-René in 1888 and Lucie in 1889, and Carrière's father and his brother Ernest were also living with them in their small apartment.[27]

At the same time Carrière began to receive honors at the Salon he was becoming acquainted with the brilliant literary and artistic avant-garde of Paris. Early in 1886 he met Jean Dolent, the Symbolist writer and critic who was to become his most enthusiastic and vocal champion, and Dolent introduced him to the broad spectrum of artists and writers who belonged to the dinner club Les Têtes de Bois.[28] No record of who was present at these monthly dinners from 1886 through 1889 has survived, but from the

3.

Auguste Rodin

Psyche

1886

Marble, 24 × 11½ × 10½ in.

Musée Rodin, Paris (S1028)

Photographed by Adam Rzepka

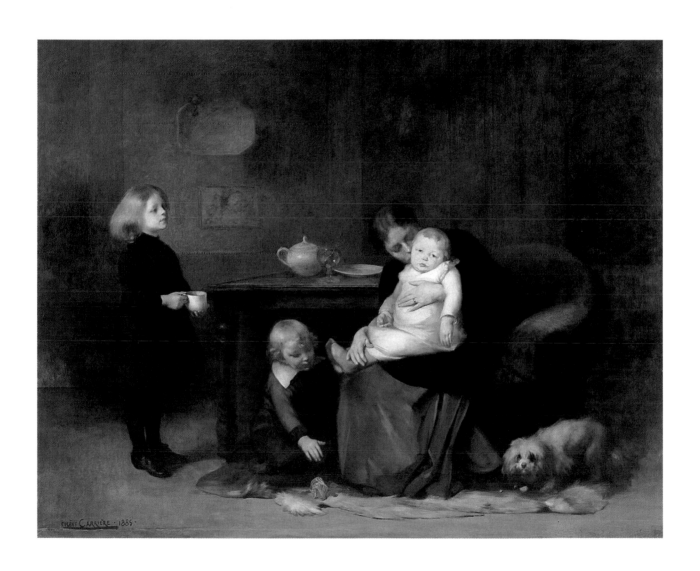

4.

The Sick Child

1885

Oil on canvas, 78¾ × 98 in.

Musée d'Orsay, Paris

"Echos divers et communications" columns in *Mercure de France* we know that among those who attended in varying degrees of regularity from December 1890 to April 1894 were the artists Félix Bracquemond, Odilon Redon, Paul Gauguin, and Jules Chéret; the poets and writers Frantz Jourdain, Jean Carrère, Mme. Rachilde, Charles Morice, Jean Moréas, Julien Leclerq, and Edouard Schuré; the critics Yvanhoë Rambosson, Roger Marx, and Gabriel Séailles; the art dealer Le Barc de Boutteville; and the genius of the Symbolist theater, Paul Fort.

In 1888 Carrière met the wealthy publisher and art collector Paul Gallimard, as well as the influential critic Gustave Geffroy. Geffroy introduced him to Edmond de Goncourt and to the regular gatherings of artists, critics, and poets at de Goncourt's salon, Le Grenier.[29] That same year Carrière also began what was to become a long association, both personal and professional, with the critic Gabriel Séailles, who would later become his biographer.[30]

Carrière's triumphs at the Salons of 1886 and 1887 soon began to bring him a few portrait commissions, among them one to paint Paul Gallimard's wife. The *Portrait of Mme. Gallimard* (Fig. 5) was shown at the Exposition Universelle in Paris in 1889, along with *Intimacy*, a family scene. Carrière received a first-class medal, and at the urging of Gustave Geffroy he was made Chevalier de la Légion d'Honneur by Georges Clemenceau, the minister of arts.[31] Thereafter, Carrière's work was warmly received by critics and public alike. Finally, at the age of forty, he had achieved not only critical success but also a measure of financial stability. At the request of a number of young artists, he opened a teaching studio on the boulevard de Clichy. Gustave Leheutre, the painter and graphic artist, was among those who studied under Carrière.[32]

In 1889 or 1890 Carrière apparently joined the newly formed Société des Peintres-Graveurs Français and was soon elected its president (Bracquemond and Rodin had preceded him in the post).[33] About the same time, at the urging of his friends Albert Pontremoli, a lawyer-collector, and Duchâtel, a printer, he began exploring lithography as an art medium. By the end of 1890 he had used the four lithographic stones Pontremoli and Duchâtel had given him to produce his first art lithographs, including *Newborn with Bonnet* (Fig. 6).[34] Over the next several years many of his prints were used as frontispieces or published in print

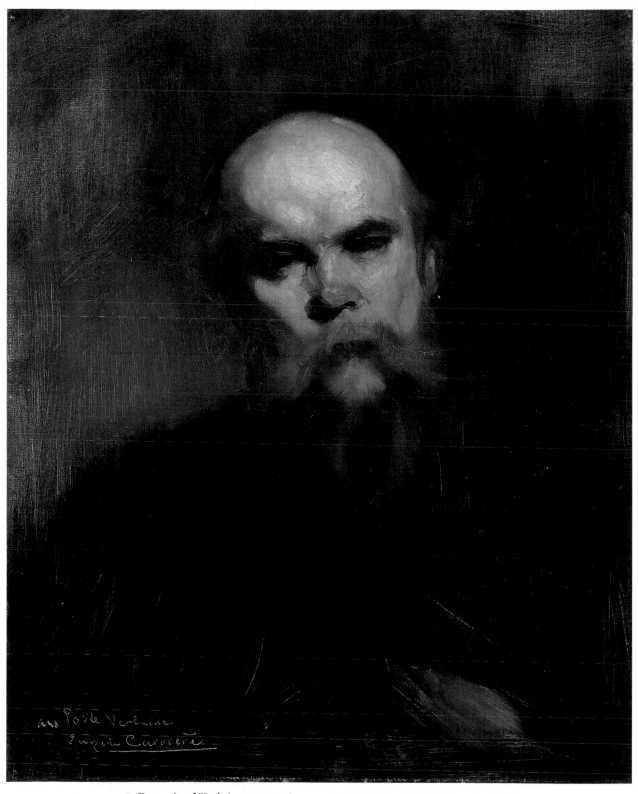

7. *Portrait of Verlaine*, 1890. Oil on canvas, 59×48 in. Musée du Louvre, Paris

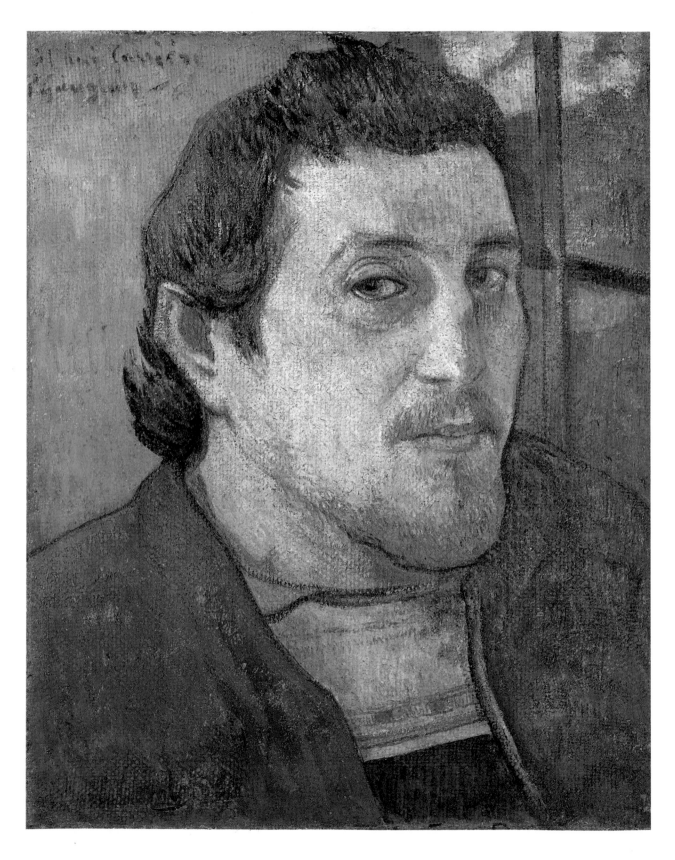

collectors' series, notably *L'estampe originale*.

Despite his own recently won stature at the Salon des Artistes Français, in 1890 Carrière joined Puvis de Chavannes, Rodin, Bracquemond, and other artists in founding the Société Nationale des Beaux-Arts in protest against the official Salon's restrictive selection process and awards criteria.[35] That year Carrière exhibited six paintings, including *Sleep* and *Tenderness*, at the new "salon without medals." Among the seven paintings he showed in 1891 were his portraits of the writer Alphonse Daudet and his daughter, Gustave Geffroy, and the Symbolist poet Paul Verlaine (Fig. 7).

Carrière had probably met Verlaine in 1890 at the Café Voltaire in the place de l'Odéon, where every Monday night at nine o'clock there was a regular meeting of Symbolist artists, poets, and critics—among them Rodin, Gauguin, Verlaine, Jean Moréas, Charles-Albert Aurier, Jean Dolent, and Alfred Vallette (editor of *Mercure de France*)—most of whom were already regulars at Dolent's monthly Têtes de Bois dinners.[36] Carrière also soon began to be seen at many of the lavish dinners that were held in Paris during what have been called the "banquet years" of the 1890s and early 1900s. In 1891 Charles Morice asked Carrière to sit next to him at the dinner held on February 2 to celebrate the publication of *Pèlerin passioné* by Jean Moréas. Stéphane Mallarmé presided, and most of the hundred guests were either artists and poets associated with Symbolism or critics favorably disposed to it.[37] A few weeks later, on March 23, most of the same people, including Rodin and Carrière, were present at the farewell banquet for Gauguin, who was about to leave for Tahiti.[38]

Carrière's friendship with Gauguin was brief but intense. "Carrière and Gauguin!" Charles Morice wrote some years later. "These are two contemporaries who seem separated by centuries. They will be rejoined when time ends. Their reciprocal esteem is an important lesson."[39] The two men met, probably at the Café Voltaire, in the fall of 1890, when Carrière's presence in the Paris art world was already well established and Gauguin's was only starting to be felt.[40] They were both at the dinner for Moréas on February 2, 1991, as well as the February Têtes de Bois dinner held three days later.[41]

"My dear Carrière, if I may call you that," Gauguin began an undated letter that must have been written soon after they met.

I listened with pleasure last night to M. Dolent relating to me your conversation with him about my portrait. As artists, our greatest satisfactions are those that come directly from art. And I am particularly sensitive to your judgment, *you, a great artist*. What does the hostile opinion of ignoramuses and imbeciles matter if one is understood by a refined person like you. I repeat then that your esteem is doubly for me the great reward of my work. Coming also from the mouth of a man like M. Dolent, it has struck chords buried deep within me. Like a small light in an eye painted by Carrière.[42]

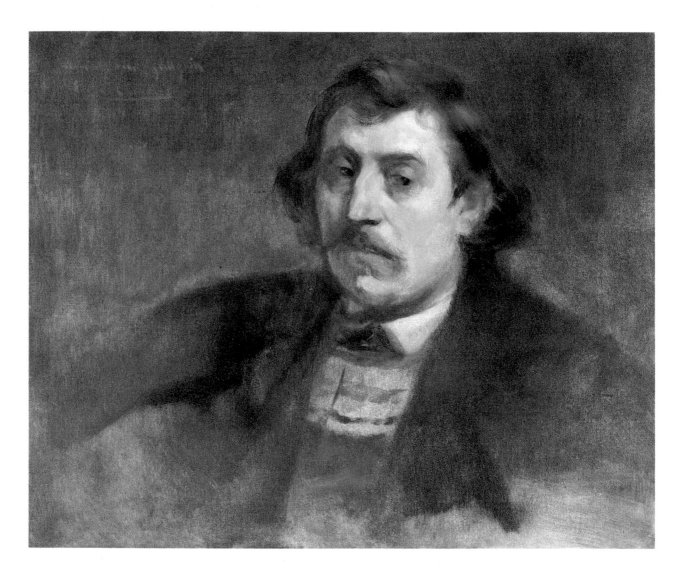

9.

Portrait of Paul Gauguin

1891

Oil on canvas, 21½ × 25¾ in.

Yale University Art Gallery, New Haven, Connecticut

Bequest of Fred T. Murphy

Which portrait Gauguin was referring to is not clear. Soon after they became acquainted Carrière offered to do Gauguin's portrait, and Gauguin gave him a self-portrait in return. Morice, who knew both artists well, reported that there were only three sittings for Carrière's portrait of Gauguin,[43] probably in early March 1891.[44] Before he left for Tahiti in late March Gauguin gave Carrière a *Self-Portrait* (Fig. 8), probably painted in 1889 or 1890, inscribed *A l'Ami Carrière — P. Gauguin*.[45] Carrière included his *Portrait of Gauguin* (Fig. 9) in his first one-man show, which was mounted at Joyant's on the boulevard Montmartre later that year. (Gauguin's wife took the portrait from Carrière in December 1892, when she was in Paris collecting works for her husband's show in Copenhagen.)[46]

Just before he must have sat for Carrière, in January or February 1891, Gauguin was asked by the Symbolist playwright Mme. Rachilde, through the intervention of Dolent, to design the frontispiece for the publication of her collected works.[47] Gauguin took as his theme Rachilde's play *Madame La Mort*. His first design (Fig. 10), which though it was published in *La vie moderne* in 1891 seems to have been overlooked until now, is quite startlingly unlike our usual conception of Gauguin's work.[48] The softened focus and general spiritualized quality of the image, together with the somewhat boneless, mannered effect of the figure and the emotive tone of the poetic trance, recall instead a great number of Carrière's works. Gauguin's second design for the frontispiece (Fig. 11), the one that was actually used, also seems to show Carrière's influence. As John Rewald has noted, "It is true that Dolent was a fanatical admirer of Carrière and that Gauguin may have wished to please his two new friends, the poet and the painter."[49] Gauguin does seem to have imitated the moving, dark, vaporous effects that Carrière achieved in his oils and in lithographs like *Newborn with Bonnet* (Fig. 6). A rapid pastel portrait of the wife of Daniel de Monfried that Gauguin did while he was working in Monfried's studio in the early months of 1891 also captures the Intimist tone and curving, linear rhythms so characteristic of Carrière's work.[50] And Gauguin's charcoal sketch *Profile of a Woman* (Fig. 12) has the same dreamlike quality, simple ovoid head, and grainy striations in the dark background.

On May 20 and 21, 1891, two months after Gauguin left for Tahiti, the Théâtre d'Art held benefit performances for him and Verlaine. Carrière executed a stage flat for Maeterlinck's *L'intruse*, a gesture of affection and esteem for the painter and the poet.[51]

In 1891 Carrière exhibited not only at Joyant's but also at Boussod, Valadon et Cie. (Geffroy wrote the preface to the catalogue), and at Goupil's on the boulevard des Italiens. That year, too, he was honored by two public commissions. The first, from the city of Paris, was to decorate six spandrels in the Salon des Sciences in the new Hôtel de Ville, built to replace the sixteenth-century building destroyed by fire during the Commune uprising of 1870–71.[52] Then in late 1891 the state commissioned a painting from

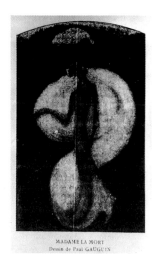

10. Paul Gaugin
Madame La Mort, 1891

11. Paul Gaugin
Madame La Mort, 1891
Musée du Louvre, Paris

12. Paul Gauguin
Profile of a Woman, 1891

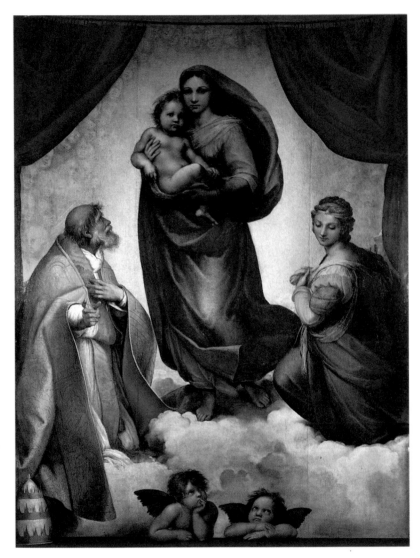

13.

Raphael

Sistine Madonna

c. 1515

Oil on canvas, 106 × 78½ in.

Staatliche Kunstsammlungen, Dresden

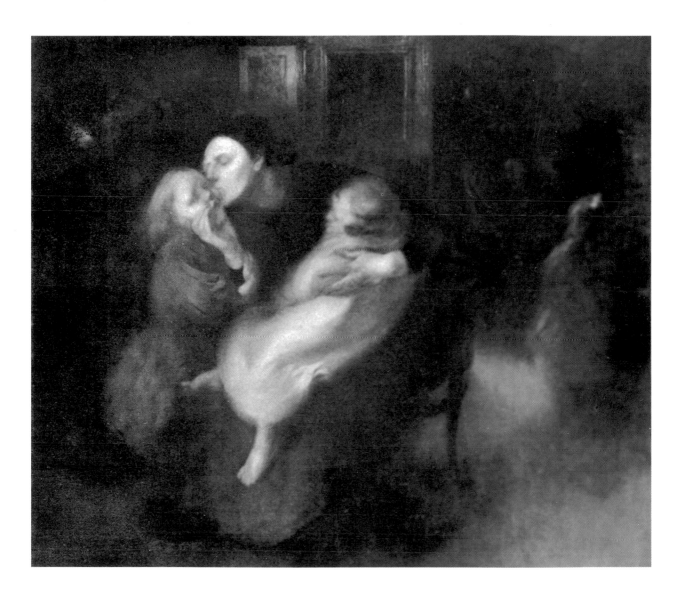

14.

Maternité

c. 1892

Oil on canvas, 60 × 72 in.

Museé du Louvre, Paris

15.

Paul Gauguin

Study for Here We Make Love, 1893

Charcoal on paper, 13½ × 8 in.

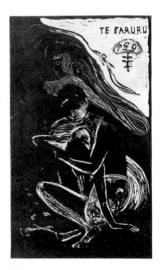

16.

Paul Gauguin

Here We Make Love

1893–94

Woodcut, printed using stencils, 14¹⁄₁₆ × 8¹⁄₁₆ in.

Museum of Modern Art, New York

Gift of Abby Aldrich Rockefeller

Carrière for the national collection of masterpieces by contemporary artists to be placed on permanent exhibition in the newly established Musée du Luxembourg in Paris. He showed his *Maternité* (Fig. 14) at the Société Nationale des Beaux-Arts salon of 1892 before it entered the museum's collection.[53]

When he reviewed the official Salon at the Palais des Champs-Elysées for *La revue blanche* in 1892, the art critic and Nabis artist Maurice Denis described Carrière as an "admirable master" and noted how pervasive his influence had become by referring to a "school of Carrière."[54] In his review of the same Salon for the *Gazette des beaux-arts*, Edmond Potier remarked that Carrière was starting to collect a number of followers, notably Constantin Le Roux at the Champs-Elysées Salon and Armand Berton at the Champ-de-Mars Salon.[55]

Gauguin arrived back in Paris on August 3, 1893, and he and Carrière resumed their friendship. That Gauguin's respect for Carrière, the "great artist," had not diminished is apparent from his comments in an article published in *Essais d'art libre* in February 1894: "Through that covering veil the colors declare themselves, the modeling makes itself felt. . . . Carrière is a French master."[56]

Soon after he returned to France in 1893 Gauguin began working with Charles Morice on writing *Noa Noa*, based on Gauguin's Tahitian experience.[57] It was also then that Gauguin started to work in woodcutting, perhaps feeling that in that medium he could capture the life and folklore of his Pacific paradise. *Here We Make Love* of about 1893–94 (Fig. 16),[58] from Gauguin's first set of ten woodcuts, illustrates his preference for reversing the usual figure/ground–black/white relationship of woodcuts. When one compares the woodcut with Carrière's *Meditation* of about 1890–95 (Fig. 17), it is apparent that Gauguin used similar means to model and to achieve grainy, scratchy effects. His preparatory charcoal sketch for *Here We Make Love* (Fig. 15) is even closer to Carrière's style, which was more easily adapted to charcoal than to woodcutting. The striations above and to the right of the figures recall Carrière's innovative use of the rubbing crayon and the textures and patterns he created by working thin paint with a stiff brush, though Carrière would never have transformed these effects into representational images like the apparition that floats above Gauguin's figures. By the time the first set of woodcuts were finished in 1894, however, Gauguin's work had developed a thematic, visual, and technical complexity that was unrelated to Carrière's depictions of intimate, poetic domesticity. In the dark, mysterious *The Universe Is Created* (Fig. 18),[59] the variety of textures heralds the beginning of new technical explorations and represents an entirely new esthetic.

Gauguin and Carrière were seen together at the Têtes de Bois dinner in February 1894. They were also both present at the banquet held in honor of Puvis de Chavannes early in 1895.[60] After the disastrous sale of his work on February 18 of that year, Gauguin again departed for the South Pacific. Carrière managed to arrange for him

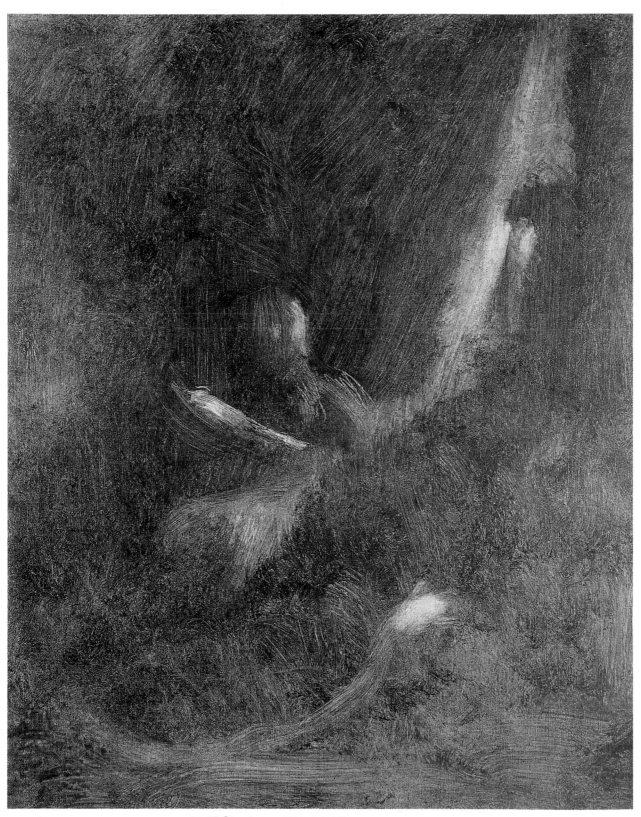

17. *__Meditation__*, c. 1890–95. Oil on canvas, 18 × 15 in.

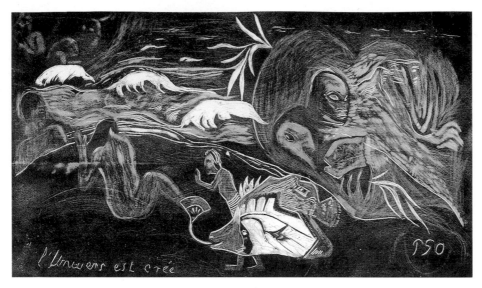

to travel in an "official" capacity at a reduced fare.[61]

By the mid-1890s Carrière's status in the Paris art world was such that seldom did reviewers fail to mention him. In his 1894 Salon review Téodor de Wyzewa, the Symbolist theoretician and critic, remarked that several artists were imitating Carrière.[62] The next year Roger Marx reported that "the last Salons have brought to light the increasing influence of Puvis de Chavannes and Eugène Carrière on new generations. In 1895, another, no less symptomatic, influence also predominates, that of Gustave Moreau."[63]

In January 1896 the Musée Rath in Geneva organized an exhibition of works by Carrière, Puvis de Chavannes, and Rodin.[64] The year that followed was one of the high points of Carrière's career. The state purchased another of his paintings, *Portraits* (or *The Carrière Family*), for the Musée du Luxembourg. From late February through March he showed forty works at the Libre Esthétique, the avant-garde salon in Brussels.[65] And that year too Siegfried Bing mounted a one-man show of Carrière's work that opened at Bing's prestigious Salon de l'Art Nouveau in Paris on April 18, then traveled that summer to his Gallery of Art in London.[66] Carrière's preface for the catalogue was the first published statement of his ideas and philosophy:

In the short space that separates birth and death, man can scarcely choose what path to follow, and scarcely has he become conscious of himself than the final menace appears.

In this so limited time, we have our joys, our sorrows; may they at least belong to us, may our manifestations bear witness to them, may they resemble only ourselves.

It is with this wish that I present my works to those whose thought is close to mine. I owe them an account of my efforts, which I submit to them.

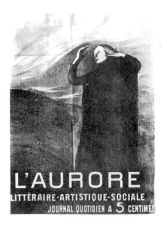

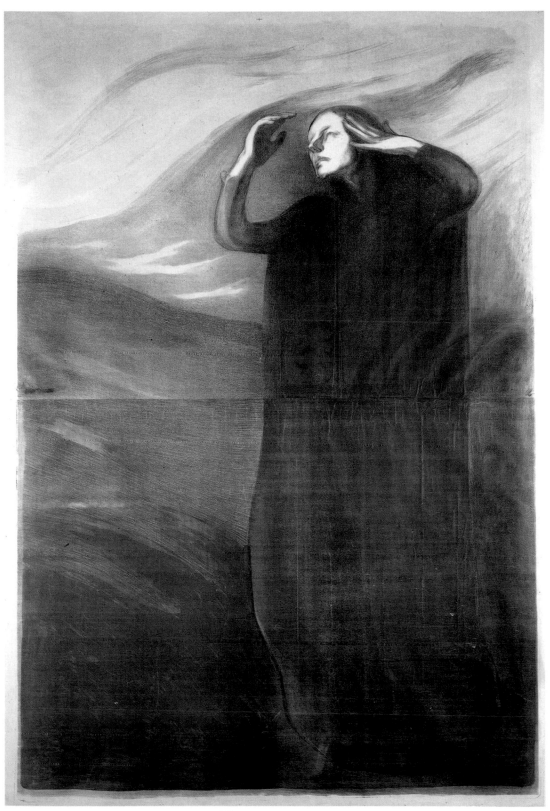

20. *L'aurore*, 1897. Lithograph

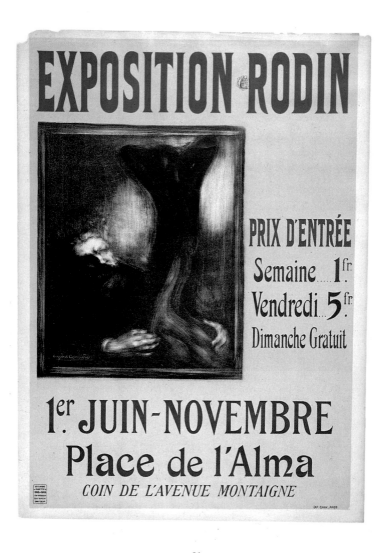

21.

Rodin Exhibition at Place de l'Alma

1900

Poster

Musée Rodin, Paris

Photographed by Adam Rzepka

I see other men in me and I find myself in them; what impassions me is dear to them.

A love of the exterior forms of nature is the means of understanding nature has imposed on me.

I do not know if reality eludes the mind, a gesture being a visible wish! I have always felt them to be united.

The moving surprise of nature to eyes forced open by a brilliant thought, the moment and the past confused in our memories and our presence, . . . all this is my joy and my concern.

Its mysterious logic imposes itself on my mind, one feeling sums up so many concentrated forces!

Forms that do not exist by themselves but by their multiple relations, everything, from a long distance, comes to us by subtle transitions; everything is an entrusted secret answering my confessions and my work is all faith and admiration.

May the works presented here give some evidence of what I love so much.[67]

No doubt because he was preparing for these shows Carrière was represented at the Salon of 1896 only by his lithograph *Edmond de Goncourt* (1896).[68]

Carrière had three other lithographs published in 1896: *Maternité* in Georges Denoinville's *Sensations d'art*, *Reading* in *Etudes de femmes*, and *Dreaming* in Dolent's *Monstres*.[69] In 1897 he was awarded a grand prize for his graphic work, as well as the Croix de la Légion d'Honneur. The same year he unexpectedly did a lithograph of a commercial nature, the poster for the newspaper *L'aurore* (Figs. 19, 20).[70] Though he had given up commercial lithography in 1889, Carrière undertook this project at the request of Georges Clemenceau, who was editor of *L'aurore*. He must also have come to see the poster as a viable art form. Three years later he did two posters, *The Miner* and *The Founder*, for the Pavillon des Mines et de la Métallurgie at the Exposition Universelle of 1900.[71] And when Auguste Rodin decided to show his sculptures in a pavilion of his own during the world's fair, he asked Carrière to do the poster (Fig. 21). Carrière, Laurens, Monet, and Besnard contributed prefaces to Rodin's exhibition catalogue.[72]

At the Salon concurrent with the Exposition Universelle Carrière showed five lithographs and eight of his paintings, among which were the *Théâtre de Belleville* he had begun in 1886 and finished some nine years later and the *Portrait of Verlaine* of 1890 (Figs. 45, 7).[73] His reputation had seemingly become as international as the Exposition Universelle, for shortly after it closed a Japanese businessman offered him a contract to acquire his annual production for 60,000 francs a year.[74] Despite the level of comfort and success he had attained the offer must have been financially attractive, but it also would

22.

August Rodin

The Eternal Idol

c. 1890

Lithograph, 11 × 8 in.

Musée Rodin, Paris (GR25)

Photographed by Bruno Jarret

23.

August Rodin

Portrait of Mozart

1911

Marble, 20⅜ × 39⅞ × 23 in.

Musée Rodin, Paris (S1085)

Photographed by Bruno Jarret

have isolated him from the art world of Paris. He chose to decline it.

At the International Congress of Social Education that year Carrière delivered the first of the seven public speeches he was to make over the next five years, "The Teaching of Art and Education Through Life":

One must go from nature to art and art to nature. How can one create interest in the expression of plastic forms in those who have not learned to understand and love them in life?

What could be more fitting here than Pascal's Thought: "What vanity there is in painting that aims to interest us in the reproduction of things that do not interest us at all in nature."

Thus art is only interesting when it speaks of things that we have learned to know. Thus images of those who are dear to us move us. It is through education, through the teaching of objective forms, that we must prepare man to see figure and meaning expressed in art. . . .

To recognize ourselves in works of art, it is indispensable that we have a sense of our being, which we gain through comparison. We must thus begin by studying our fellow creatures to see them in us and find ourselves in them.

Outward forms contain this lesson of the logic of the appearances of beings and things.

They develop in us the skill of analysis and the need for general harmony that takes such different names; they make us wary of works made of lies or in the latest fashion, works that are opposed to life. . . .

Visits to museums must follow familiarity with and initiation into nature. Without this preparation men pass before works of art like the ignorant before the wise, full of respect but bored; they stop at what is at their miserable level, amuse themselves in the virtuous ignorance they share, excited by the flattering ruse of a crowd pleaser.[75]

Rodin's choice of Carrière to do the poster for his great show of 1900 (Fig. 21) is significant. Carrière's mysterious image of the artist creating a sculpture seemingly from the dark atmosphere itself must have been to Rodin's liking.[76] That he thought of his sculptures as emerging from darkness is illustrated by his lithographic view of

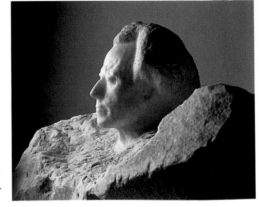

The Eternal Idol (Fig. 22).[77] The date of this lithograph is not known, but it must have been done after 1889 when the sculpture it depicts was conceived. The similarity of this image to Carrière's lithographic work is striking; Rodin had given Carrière a marble of *The Eternal Idol*, and it is possible that the painter's appreciation of the work may have inspired Rodin's lithographic interpretation of it.[78]

From the late 1890s on, when his association with Carrière was marked by several public gestures of mutual affection and the two men are known to have traded works, Rodin's sculptures took on a poetic, spiritual, or as Elsen has put it, "feminine" quality.[79] This change of temperament coincided with the sculptor's having started to work almost exclusively in marble, on smaller works intended for the homes of collectors. The *Portrait of Madame F . . .* (1898), *Earth and Moon* (1899), *The Last Vision* (1908), *Portrait of Mozart* (1909; Fig. 23), and *Lady Sackville-West* (1912–13) are among a great number of works that exemplify the fruition of this esthetic in Rodin's oeuvre from the turn of the century.[80] As in the paintings of Carrière, these images are not so much records of the physical existence of their subjects as they are evocations of their spiritual essence.

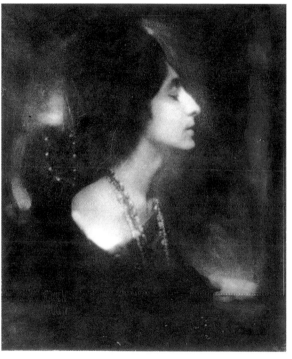

Carrière influenced not only how Rodin interpreted his figures but how he thought they should be viewed. To heighten the "mystère," the pervasive atmosphere in which he thought his works should be bathed, Rodin liked to observe his sculptures at night by candlelight, and he was even planning to have his great portal *The Gates of Hell* illuminated from below.[81] He also had Edward Steichen photograph him and his work by moonlight.[82]

Steichen had left Milwaukee in 1900 to study art in Paris. He arrived in May, and one of the first things he did was visit the Rodin pavilion near the Exposition Universelle. It was just before closing hour, he recounted later, and the light was dim.[83] Carrière's poster, his catalogue preface, and the evening light all must have affected Steichen's first impression of the sculptures he had so long been anxious to see.

The Norwegian landscape painter Fritz Thaulow, who had hired Steichen to photograph his children, introduced him to Rodin in 1901, and thereafter until he returned to the United States in the summer of 1902 he visited the sculptor every Saturday in his studio on Meudon.[84] It is quite possible that the young American met Carrière there, and he must certainly have seen the nine oils by Carrière that were among Rodin's collection of paintings. And he must have been acquainted with the painter's work even before he met Rodin, for in an article published in *Photogram* in January 1901 he

24.

Edward Steichen

Mercedes de Cordoba

1904

Gelatine-carbon print

Metropolitan Museum of

Art, New York

Alfred Stieglitz Collection,

1933 (33.43.3)

commented that "Carrière, one of the greatest of modern French painters, keeps all his pictures in a low brownish key, using no pure whites or darks; and blending his tones, he secures an exquisite feeling of atmosphere and shrouds that in a lovely sentiment."[85]

Steichen's enthusiastic offer to photograph Rodin and his sculptures resulted in a number of innovative, "painterly" photographs, among them *Rodin: The Thinker* of 1902, which reflect the photographer's appreciation for Carrière's style, with its softened focus and atmospheric effects and forms emerging mysteriously from a primal darkness.[86] And other examples of Steichen's work, such as *Mercedes de Cordoba* of 1904 (Fig. 24), also capture the Intimist, trancelike aura and even the textural quality of Carrière's art.

In 1900 Carrière founded his "School of the Street," which seems to have been a series of regular meetings open to anyone interested in hearing his social, moral, and artistic philosophies.[87] The motivation to share ideas and to enlighten anyone, even poor workers, was yet another sign of Carrière's fervent socialist commitment. His desire to educate others had already led him in 1890 to begin accepting students at his studio in the boulevard de Clichy. By 1895 Roger Marx was reporting in his review of that year's Salon that young artists "covet the teaching of Gustave Moreau, Eugène Carrière, and Paul Gauguin."[88] Before or during 1899 Carrière moved his classes to a studio run by an Italian model by the name of Camillo at 76, rue de Rennes in the cour du Vieux-Colombier. By 1900 he had enrolled his fiftieth student, a Mme. Hertz-Eyrolles.[89] Fernande Oliver, who would later become Picasso's mistress, was among his students. And Henri Matisse, André Derain, and Jean Puy, along with the other artists who in the next decade would be known as the Fauves—Camoin, Manguin, Biette, Laprade—came to study at what Matisse called the "Académie Carrière" after their master, Gustave Moreau, died in 1898.[90]

As a teacher Carrière was open to any and all of the stylistic explorations of his students. Matisse said of the two years he spent studying at the rue de Rennes: "At last it was possible to work in peace, for the professor corrected only his 'pet' pupils, the tame ones of long standing, and reserved his judgment on the more personal work of the rest. Indeed, Carrière never said a word to me. I didn't know what to think, but some years later he told me he wished to respect my ideas, which interested him."[91] It is ironic that so many of the Fauves who shocked the art world at the Salon d'Automne in 1905 with their explosive use of color had studied under Carrière. Yet with exception of Laprade, Carrière seems to have had little effect on the Fauves. Mme. Hertz-Eyrolles recounted that Carrière was not as much concerned with teaching art as he was with instilling in his students ideas about the meaning of life, man's relation to nature, and the wonders of the universe.[92] Carrière's belief that the world is made up of spiritual energies may have been the philosophical starting point for the Fauves, who substituted the emphatic stimulation

of color for his Symbolist evocations of unseen universal forces.

The "Académie Carrière" remained open until 1903, when Carrière's poor health forced its closure. The critics continued to take note of, or even anticipate, Carrière's influence on the next generation. In 1902 Félicien Fagus reviewed an exhibition at the Galerie Weil of works by four young Spaniards, one of whom was Pablo Picasso: **They still don't have their great master, the conqueror who absorbs all and renews all, relative to whom everything is dated, who fashions an unlimited universe. They advantageously remember Goya, Zurbarán, Herrera and are stimulated by our Impressionists – Manet, Monet, Degas, Carrière. Who – the moment is ripe – will become their El Greco? It is true that this great initiator of Iberian art wasn't born a Spaniard; and, of course, who knows? So . . . Carrière perhaps.**[93]

Although as a child he had had only a few years of formal education, in literary as well as artistic circles Carrière's opinions were solicited on a wide variety of topics. In 1901 he made the acquaintance of Isadora Duncan and lectured on her role in the development of modern dance, and between 1903 and 1908 eight more of his texts were published.[94]

Carrière's lectures, writing, and teaching did not diminish his productivity. In the late 1890s he received his third public commission, to do a mural-scale painting for the lecture hall of the Faculté des Lettres at the Sorbonne. His *Vision of Paris* was exhibited at the Salon of 1898 before it was installed at the university.[95] In 1900 or shortly before he was commissioned to paint four panels for the city hall of the twelfth arrondissement (Reuilly) of Paris (Figs. 64–71). He continued to show his work at the "Nationale," and in April 1901 the Galerie Bernheim-Jeune mounted a one-man exhibition, *Oeuvres récentes par Eugène Carrière*.[96] His fifth public commission came in 1902, when the French government asked him to do a painting to commemorate the visit of members of the British Parliament planned for 1903. Reproductions of Carrière's *Kiss of Peace* (or *L'entente cordiale*) were distributed for the occasion, and it was also used on the cover of the menu for the banquet held to honor the British visitors on November 26, 1903.[97]

That two monographs on Carrière were published during his lifetime is yet another measure of his achievement. Gustave Geffroy's copiously illustrated *L'oeuvre de Eugène Carrière* (incorporating many of the ideas he had expounded in his frequent pieces on Carrière in the annual *La vie artistique* from 1892 on) appeared in 1902,[98] just a year after Gabriel Séailles published *Eugène Carrière: L'homme et l'artiste* (a greatly expanded version of a long article he had written for the July 1899 issue of *Revue de Paris*).[99] In December 1901 *Les maîtres artistes* devoted an entire issue to Carrière. The longest of the several articles was "The Visionary Painter" by Léon d'Agenais, who most thoroughly expressed the similar ideas that appeared in the articles by Geffroy, Séailles, Marcel Délas, Camille Mauclair, and Auguste Dorchain. D'Agenais viewed Carrière's art as an

exteriorization of the soul and a dematerialization of the individual, but unlike the other authors he also dwelt on the stylistic and philosophic relationship he saw between Carrière's images and the Biblical creation of light that brought life out of the primal chaos. The issue also included Edmond de Goncourt's "Souvenirs," an article first published in 1892 on Carrière's career and works, and "From a Louvre Painting to Eugène Carrière," in which André Mellerio likened the artist's dark atmospheric effects to the works of Leonardo and his painterly effects to those of Van Dyck and Velázquez.

After several years of declining health Carrière finally acknowledged that he had cancer of the throat and underwent surgery on September 28, 1902. (The surgeon, Dr. Jean-Louis Faure, was the older brother of the art critic Elie Faure, whose monograph on the artist would appear in 1908.) Possibly because he was still recovering from his operation, in the spring of 1903 Carrière was absent from the Société Nationale des Beaux-Arts' salon. But he might also have withheld his work because he was planning to participate in the new Salon d'Automne, of which he was honorary president. As early as August 1902 *Mercure de France* had mentioned that Carrière was a member of a group of artists and critics who intended to establish a new salon in protest against the restrictive selection rules of the Société Nationale, which barred exhibitors who had shown with other salons.[100] He believed that artists needed and deserved as many opportunities as possible to present their work. He exhibited three paintings at the Salon d'Automne of 1903 and also showed there in 1904 and 1905. In 1904 he resigned his membership in the Société Nationale, of which he had been a founding member.[101] Yet in 1905 the Nationale accepted and exhibited his recently executed *Portrait of Mme. A. Devillez and Her Son M. L. H. Devillez*, thereby overriding its own rule.[102]

In spite of Carrière's poor health he continued to work. Bernheim-Jeune showed sixty-five of his works in 1903. The accompanying catalogue included essays by Edmond de Goncourt, Gabriel Séailles, Gustave Geffroy, Camille Mauclair, Roger Marx, and the artist himself (his 1896 Salon de l'Art Nouveau preface).

In 1903 Gauguin died in the Marquesas Islands. The November issue of *Mercure de France* carried a short article by Carrière in which he mourned the loss of such a great artist, whose genius had been recognized only by those who were close to him. As might have been expected, however, he mixed his praise with reservations about his friend's art, "rich and subtle in nuance and new in spirit, but impatient in its philosophy."[103] *The Death of Gauguin*, or *Grief* (Fig. 25) was Carrière's visual tribute to his friend.[104] The Christlike figure is unmistakably Gauguin, identifiable by his distinctive profile. The sacred theme was appropriate. Gauguin, who viewed himself as an artistic messiah, had used this same conceit in his own religious works, such as *Christ in Gethsemane: Self-Portrait*. In effect, Carrière created a secularized pietá, lamenting Gauguin's death in a way he would have appreciated.

In the fall of 1904 Carrière and his wife moved to Mons, Belgium, where he underwent X-ray treatments for his cancer. He returned briefly to Paris for the extraordinary banquet the sculptor Emile Bourdelle organized in his honor at the Restaurant Vautier on December 20, 1904. Of the many dinners of the age, Carrière's, over which Rodin presided, was certainly one of the largest, with 500 guests in attendance.[105]

At the Exposition of Fine Arts in Munich (where he had already exhibited in 1896 and 1899) Carrière was represented in 1905 by several paintings, among them *Intimacy* (1903; Fig. 26) which had received a gold medal at the Universal Exposition in Saint Louis in 1904. In 1905 he also participated in the Berlin Sezession, and he showed in Dresden as well.[106] In September of that year at the Universal Exposition in Liège, Belgium, where he exhibited a work titled *Painting* (1899), Carrière delivered a speech, "The Apparition of Nature," in the Pavillon des Beaux-Arts. He began with these comments:

A work of art requires respect for the proportion of volumes and values, the sense of their proportionate interest in regard to the whole.

To best clarify this statement, let us consider the human figure. We can easily understand how the different parts of the body have specific proportions; some present us with strong surfaces, large and solid planes; others, more discrete, accompany them, enhance them according to their relative interest, and we thus give total expression to life through the harmony of unity.[107]

Carrière and his wife then returned to Paris for the 1905 Salon d'Automne, the last exhibition he would participate in during his lifetime.[108]

On November 2 at the Clinique des Frères Saint-Jean-de-Dieu Carrière underwent further surgery for cancer of the throat. Though he survived the operation, he was paralyzed on the left side and never regained his speech. After he had returned home to the Villa des Arts numerous friends came to visit, among them Pablo Casals, who played his cello to help ease the artist's pain. Finally, in the early hours of March 27, 1906, Carrière started to hemorrhage and died at the age of fifty-seven.[109]

The funeral at the cimetière Montparnasse on March 29 was large and impressive. Rodin, Séailles, Frantz Jourdain, Charles Morice, and others delivered eulogies.[110] Rodin, his dearest friend, said:

What an honor that this great artist was poor! He has revealed to us the wealth of love, the true wealth that is not material; and his genius sprang only from natural forces. Thus he was able to attract a host of secretly fascinated intellects. Little by little they were drawn to him (none after drew away); yet while the crowd of his admirers grew numberless, he still stood out. Those who will understand him, those who are to come, will work even more for his glory.

25.

The Death of Gauguin (Grief)

1903

Oil on canvas, 29½ × 36¾ in.

The collection of

Joey and Toby Tanenbaum, Toronto

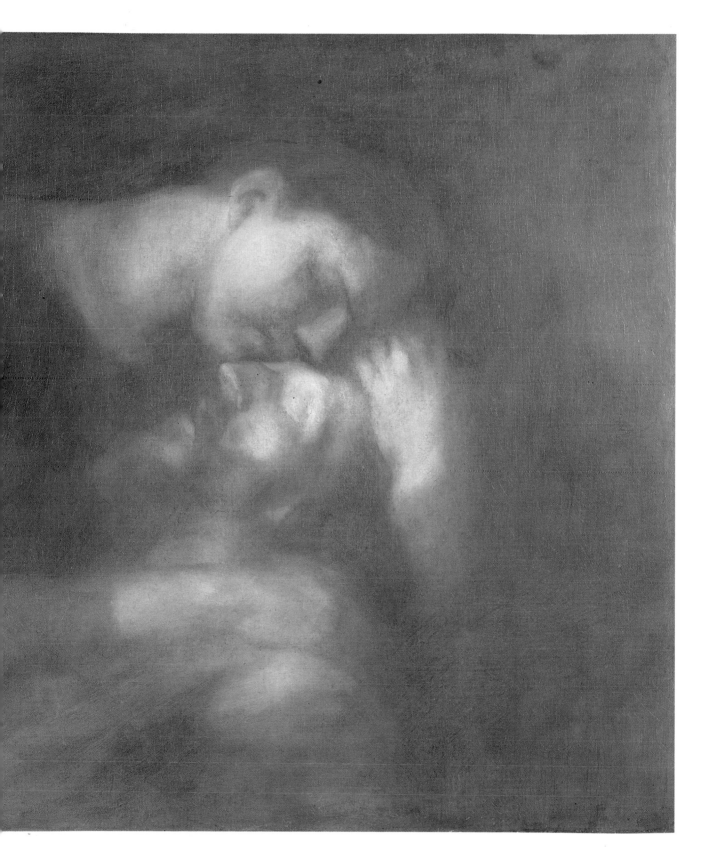

Abundant source of wisdom, his work speaks intimately of hope; it shows us the joys that are close to us, where out of habit we neglect to look: Carrière, benefactor, spirit informed of the only realities, teaches us that our innermost being is rich in treasures; he sets ajar the door to that charming country which is ourselves.

Beyond this, he has reawakened in us the spirit of admiration. Great go-between, great intimate of beauty, he has led us to understand the beautiful epochs, such as the antique. – He has reopened sources.

Man of good will, having found the true pathway, he is a guide for future artists; his work continues to counsel them. It will lead them through wisdom to glory.[111]

On the first anniversary of his death many of Carrière's friends and admirers gathered at his grave in remembrance.[112] The "Dinner of Fourteen," an organization dedicated to establishing universal brotherhood that had been organized in January 1905 under the presidency of Charles Morice, with Carrière as honorary president, proposed that a street be named after Carrière. The rue Eugène Carrière, adjacent to the cimetière Montparnasse, was named in 1907. Strasbourg, where he had spent seventeen years of his youth, named a street after him that year as well.[113]

The Société Nationale des Beaux-Arts Salon of 1906 exhibited a number of Carrière's paintings in a room set aside for the occasion, and that year the Salon d'Automne had a retrospective exhibition of forty-nine of his works.[114] The sale of Carrière's studio on June 8, 1906, at the Hôtel Drouot was a notable success, netting Mme. Carrière 196,464 francs, 50,000 more than experts had anticipated. In addition to the ninety-nine works by Carrière, thirteen works donated by as many artists – Besnard, Blanche, Denis, Carolus-Duran, Cézanne, Cottet, Lebourg, Lhermitte, Ménard, Renoir, Roll, and Simon – were in the sale, as were works by Puvis de Chavannes, Delacroix, Gauguin, Lerolle, Dalou, and Rodin from the artist's collection.[115]

In March 1907 the Libre Esthétique in Brussels honored Carrière with a retrospective exhibition of significant paintings that spanned his career.[116] The Ecole Nationale des Beaux-Arts mounted a large retrospective of his works during the months of May and June and invited Charles Morice to give a speech on the art of his departed friend.[117]

In Strasbourg, which views Carrière as one of its great native artists, a show of Carrière's works opened in May 1909 in the House of Alsatian Art, established in 1905 in the former lithographic printing shop of Auguste Munch, where Carrière was apprenticed in commercial lithography.[118]

The Galerie Nunès et Fiquet in Paris had a one-man show of Carrière's work in 1916, and there were shows at Bernheim-Jeune in 1917 and 1920.[119] After the death of

Mme. Carrière in 1922 Choublier et Cie. sold her extensive collection.[120] Four years later the Galerie d'Art Contemporain organized an exhibition of 15 paintings, 111 drawings, and 24 lithographs by Carrière (Louis Vauxcelles wrote the catalogue preface). On his death in 1930 Louis-Henri Devillez, the Belgian sculptor who was a close friend of Carrière's, willed his collection of forty-six paintings to the Musée du Louvre. To commemorate the gift the paintings were exhibited in the Orangerie des Tuileries from December 1930 to January 1931.[121] Five years later the Museo Nacional de Bellas Artes and the Jockey Club of Buenos Aires organized a show of thirty-seven oils from public and private collections.[122]

The centennial of Carrière's birth, 1949, was marked by two shows: *Centenary of Carrière* at the Musée des Augustins in Toulouse[123] and *Eugène Carrière and Symbolism: Exposition in Honor of the Centenary of the Birth of Eugène Carrière* at the Orangerie des Tuileries in Paris.[124] The Paris exhibition not only heralded the beginning of a rebirth of interest in Symbolist art but also, by showing Carrière's work alongside that of his important contemporaries, recognized him as very much an influential figure of his time.

26.

Intimacy (The Big Sister)

1903

Oil on canvas

Musée d'Orsay, Paris

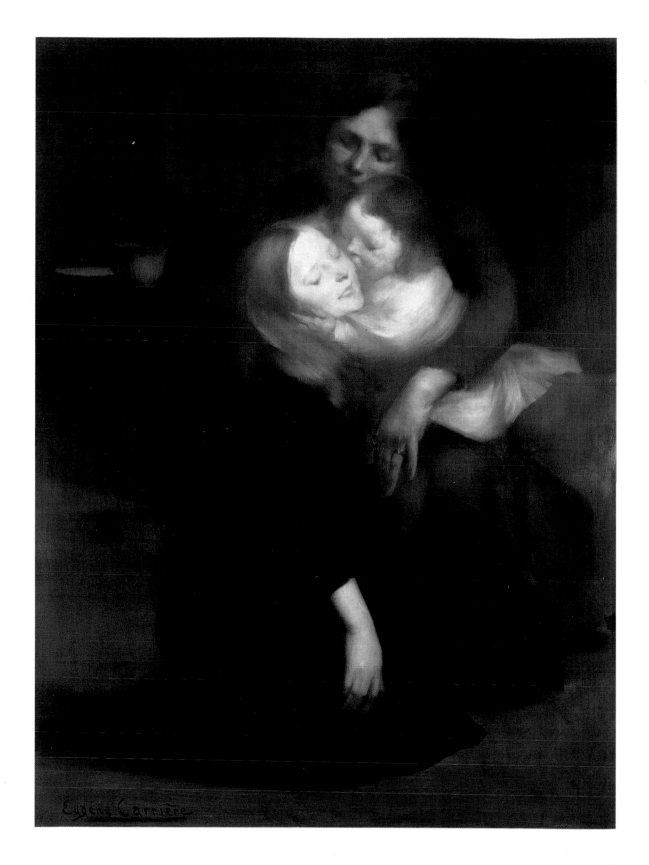

De l'oeuvre

arrière recounted late in his career that it was on seeing the paintings of Rubens in the Louvre while visiting Paris in 1868 that he was inspired to become an artist, although he described his own work of the time as being "after La Tour." It is perplexing that a young artist working in the manner of the eighteenth-century pastel portraitist, who was noted for his sense of spontaneity, incisive characterization, and cool palette, would be captivated by Rubens's sensuous, animated compositions and rich palette. One must assume that Carrière's taste at the time was unformed and unfocused, especially considering his choice of Cabanel, whose paintings have an artificial, decorative, rococo sensibility, as his master at the Ecole des Beaux-Arts.

Even though it is his most academic painting, Carrière's competition piece for the 1876 Prix de Rome, *Priam Coming to Achilles to Reclaim the Body of Hector* (see Fig. 1), broke from the classical dicta of clarity, precision, and uniform smoothness of surface. Much of the background consists of dark, unclarified areas where forms and objects melt into one another, although in the foreground the sand on which Achilles' tent is pitched is perfectly rendered. Areas that are clear and precise contrast with those that are dark and indistinct, and the surface quality varies from the smooth areas of Achilles' body to the rough texturing of the foreground or the impasto of Priam's beard and sleeve.

Although painted the same year, *Portrait of the Artist's Mother* (Fig. 2),[125] free of the academic restraints imposed by the Prix de Rome competition, is stylistically far from *Priam*. The most arresting aspect of this portrait is its factualism, reminiscent of the sober photographic portraits of the era. Mme. Carrière, in her dark dress, is starkly presented in harsh lighting against a dark background in an uncompromisingly realistic manner. The portrait anticipated the tenebrism Carrière would develop over the next decade.

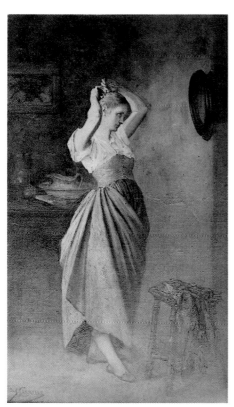

27.

Woman Doing Her Hair

c. 1877

Oil on canvas

Musée de Strasbourg

Carrière's interest in genre was a phenomenon of the early part of his career. With the exception of a few classical allegories and several portraits, all his works from 1877, when he left Cabanel's studio, to 1886, when his style and themes developed toward Symbolism, fall within the thematic range of genre, and more specifically under the rubric of "family life." *Woman Doing Her Hair* (Fig. 27) of about 1877 and several other of his paintings of the second half of that decade have a spirit reminiscent of the art of Jean-Baptiste Simeon Chardin. Like Chardin, Carrière focused on the simplicity and serenity of middle-class domesticity, choosing a common yet charming activity. The graceful pose, simple environment, and beautiful but generalized features of the woman in *Woman Doing Her Hair* all recall Chardin.

Shepherd and His Flock of about 1877–80 (Fig. 28), Carrière's only known genre

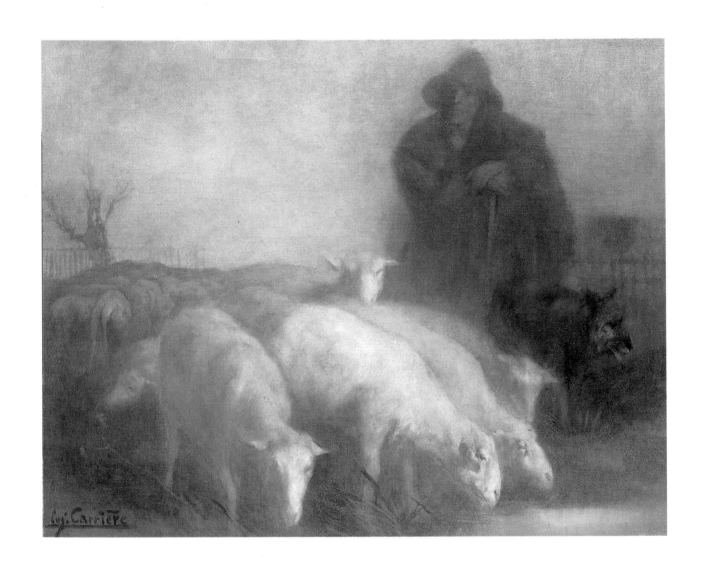

28.

Shepherd and His Flock

c. 1877–80

Oil on canvas, 22½ × 30 in.

scene in a landscape, may have been inspired by Jean-François Millet. If so, this is Carrière's sole known effort in the manner of the Barbizon master. Much like Millet's *The Sower* (1850) or *Man with a Hoe* (1859), Carrière's image is limited to what was necessary for the theme and its interpretation: a shepherd and an attendant dog, a large flock, and a landscape of little more than the horizon, a tree, and a fence. Like Millet's "heroes of the soil," the anonymous, crudely clothed figure of the shepherd towers above the horizon. In Carrière's painting, however, there is a somber, almost melancholy tone and a sense of loneliness in the desolate landscape whose single tree is bare or dead, revealing a less optimistic mind than Millet's and the propensity for poetic introspection that would come to typify Carrière's art. The color-tinted atmospheric effects in the art of Joseph M. W. Turner may have been the inspiration for Carrière's opalescent sky. He later reminisced about the months he had spent in London in 1877, "Always alone, I spent my time working and thinking. Turner was with me in spirit."[126] The dark browns of the lower half of the composition and the pinks and blues above are soft and diffused, anticipating the overall enveloping mist of Carrière's mature work.

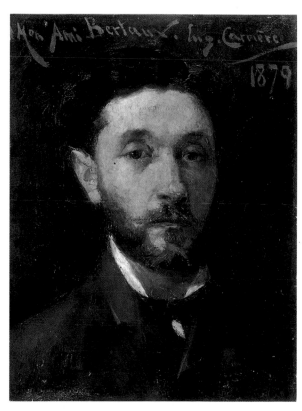

A more consistent source in Carrière's development was the art of Jean-Jacques Henner, a successful and decorated Alsatian artist who had studied at the Ecole Municipale de Dessin in Strasbourg twenty years before Carrière and whose reputation and work surely must have stimulated the imagination of the next generation of students there. An undated letter from Henner to Carrière indicates that sometime early in his career Carrière made Henner's acquaintance and sought his advice.[127]

29.

Portrait of Berteaux

1879

Oil on canvas, 22½ × 15½ in.

Museum of Fine Arts, Boston

Carrière's *Portrait of Berteaux* of 1879 (Fig. 29)[128] marks a change in his approach to portraiture from objective to subjective and a new concern with recording the spirit, rather than merely the physical appearance, of his sitter. This change coincided with a greater sensuousness and painterliness in his work and an increasingly monochromatic brown palette, techniques that serve other ends than the realistic depiction of physical appearances. Beginning in the 1860s, and even more so from the mid-1870s on, Henner had also introduced a quiet, introverted quality into his work, as is apparent in his *Self-Portrait* of 1877. And by 1877 most of Henner's paintings were almost entirely in brown, with a visual emphasis on the application of the paint.

Carrière's *Figures in Moonlight* of about 1880–84 (Fig. 30) clearly reflects the influence of Henner, who was best known for his idyllic landscapes with allegorical

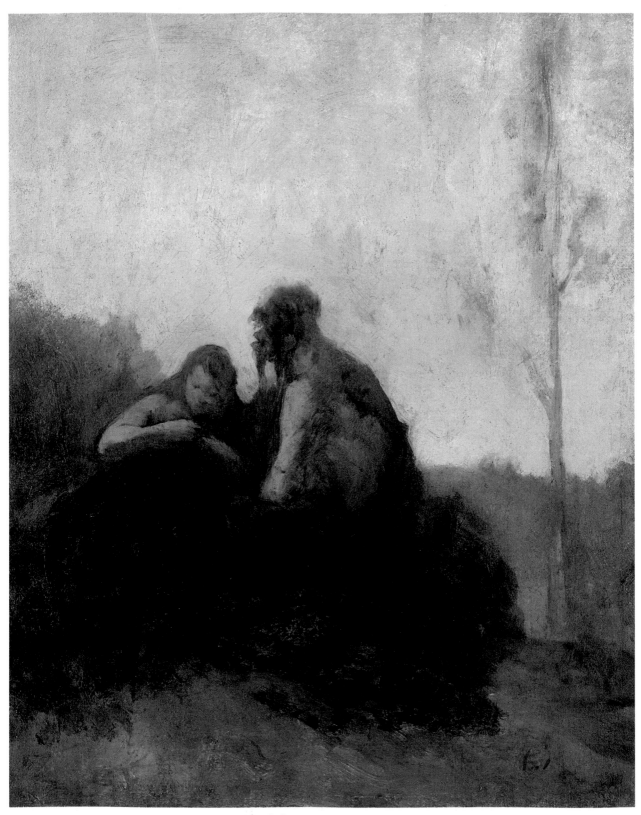

30. *Figures in Moonlight,* c. 1880–84. Oil on canvas, 15⅞ × 12⅝ in.

figures, done in a loose, painterly palette of browns and translucent blues, as in his *Nymph by the Fountain* of 1880 (Fig. 31). If Henner was a source of inspiration, it was the general character of his work that attracted Carrière. Foretelling his later development, Carrière concentrated on the creation of a feeling or mood, left his figures unindividualized and inexplicit, and emphasized the strokes, textures, and buildup of the paint.

The dominant tendencies of Carrière's art of the early 1880s were to continually reduce the importance of, if not eliminate, accessories and environments, to become looser or more painterly in technique, and to employ an either muted or monochromatic brown palette. Yet these developments did not occur uniformly in all his works. The stylistic distinction between his commissioned and Salon pieces and his other work is exemplified by comparing *Kiss of Innocence* (Fig. 33),[129] which was shown at the Salon of 1882, with a related painting, *Children Playing*. *Kiss of Innocence* emphasizes contrasts of value and has an almost achromatic palette and few apparent brushstrokes. *Children Playing* shows that Carrière also had a rich, painterly, and more spontaneous side. The paint was noticeably applied in *Children Playing* both as a thick impasto and with a dry brush, so that the texture of the canvas shows through two successive layers of pigments. *Kiss of Innocence* has a far greater sobriety of tone and emphasizes theme over technique. Because the same two figures, perhaps even identically dressed, appear in both paintings, the contrast of technique is all the more apparent. This is not an isolated instance. Most of Carrière's paintings fall into one of two groups. His commissioned and Salon pieces are generally smoother, with little evidence of brushstrokes or the texture of the canvas. Instead, they rely on the subject and gradation of light and dark for effect. Most of his other works are technically much looser and much more varied and innovative. The division between these two types of oils had gradually diminished by the turn of the century, although it never completely disappeared.

Carrière's works of the early 1880s were not conceived as somber, stark images. The *Study for Kiss of Innocence* (Fig. 32), surely a spontaneous sketch which only later took its final form in the Salon oil, reveals that he was thinking in terms of normal light conditions and modeled, three-dimensional forms. In the final oil, the scope of the image has been reduced to focus on the interaction of the two children who are set before a dark, neutral plane so that all sense of placement or environment is lost. Furthermore, the lighting in the Salon oil is harsher, so that the baby's white outfit reads virtually as a solid white area. The underside of his extended arm is the only modeled form in the composition. The girl's black jacket, as well as her brown hair, melts

31.
Jean-Jacques Henner
Nymph by the Fountain
1880
Oil on canvas, 95 × 70 in.
Musée Jean-Jacques
Henner, Paris

32.

Study for Kiss of Innocence

1882

Brush and wash, 4¼ × 5⅝ in.

Fogg Art Museum, Harvard University,

Cambridge

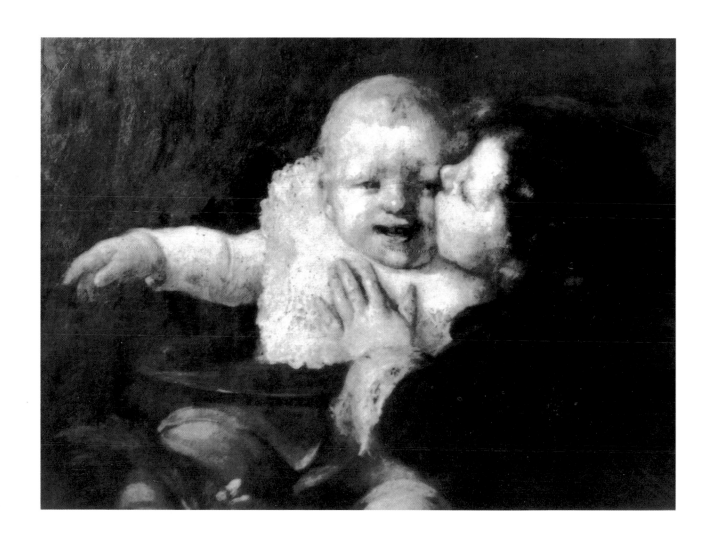

33.

Kiss of Innocence

1882

Oil on canvas, 62 × 80 in.

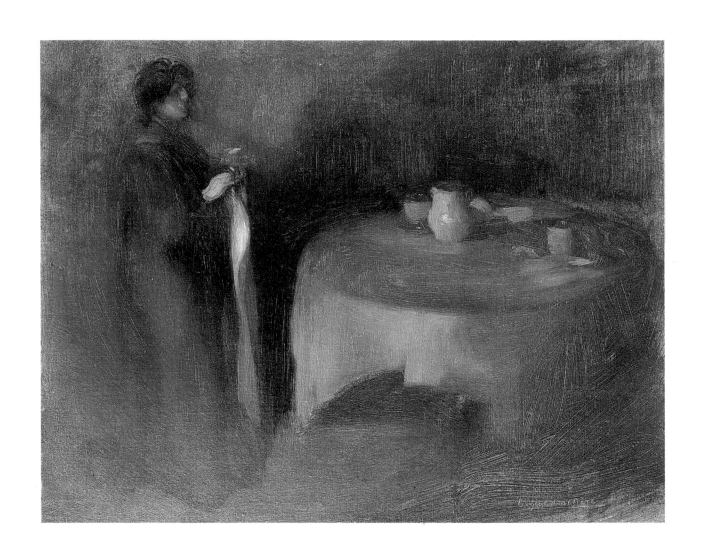

34.

Woman Laying a Table

c. 1885–90

Oil on canvas, 13¾ × 17¾ in.

into the flat darkness. In the Salon oil Carrière restricted the sense of space and the range of his palette, eliminated accessories, and altered the lighting for stylistic and thematic purposes. He stripped the painting of all but the basic visual and expressive essentials, renouncing natural space, light, and color in the process.

Carrière believed that all of life and the living world about him had meaning. In his work seemingly insignificant activities acquired a sense of mystery. *Woman Laying a Table* (Fig. 34) was painted about 1885–90, a period when Carrière's style was quickly maturing as he moved further from naturalism toward a sense of mystery made manifest in paint. The figure is barely discernible from the area around her, and the table, too, fuses with the dark undefined environment in which its top appears to float. *Portrait of a Boy* (Fig. 35),[130] a commissioned work of 1886, is another example of this development. Carrière reduced his palette primarily to brown, black, and white, concentrating his attention on subtle modulations of value. And the introduction of a visually obscuring atmosphere produced further effects of indistinctness and fusion that led him to eliminate the traditional figure–ground relationship. By 1886, even in commissioned portraits, Carrière's figures had begun to appear as if they were emerging from a dark atmosphere.

As he reduced his palette to browns in the early 1880s, Carrière's work moved toward the tradition of tenebrism, first practiced by Caravaggio and the artists influenced by him in the seventeenth century, in which forms are dramatically revealed by the force of light penetrating a brown or black primal darkness. But by the late 1880s Carrière had also softened the clarity of his forms. As more than one critic commented at the time, the softened focus was very likely inspired by the moisture-laden sfumato of Leonardo, whose masterful use of chiaroscuro must also have impressed Carrière.[131] (In an article of January 1908 in the *Tribune médicale* Carrière's physician stated that he had examined the artist's eyes in 1900 and that in every respect his vision was perfectly normal, laying to rest any speculation about whether color-blindness and myopia might have accounted for the monochromatic brown palette and lack of sharp focus in Carrière's paintings.)[132]

Yet the exigency of Carrière's era was increasingly directed toward the material potentials of painterly effects, as was evident in the work of the Impressionists of the previous decade and even in the teaching of academicians, most notably Thomas Couture. For three decades Couture had stressed underpainting as crucial to the finished work because it embodied an expressiveness and freshness of execution that were normally eliminated and hidden by the more controlled application of successive layers of paint. Students were told to allow the underpainting to show through in some passages of the finished painting. Albert Boime has noted that Carrière "substituted the monochromatic *ébauche* for the conventional picture, welded the deeply felt underpainting to his theme of maternity. In this he was quite deliberate; the *ébauche* constituted the ideal pictorial expressiveness in definitive works."[133] Underpainting is traditionally done in

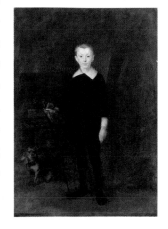

35.

Portrait of a Boy

1886

Oil on canvas, 70⅜ × 48¼ in.

Art Institute of Chicago

Gift of Mrs. Chauncey

McCormick (1956.341)

browns to establish the composition and the relative values. Primarily in his non-Salon and noncommissioned works, Carrière's "underpainting" was followed not so much by overpainting as by modifying values and creating textures and patterns by working the wet surface with brushes and wiping and scratching. The technique he developed might be best described as subtractive, rather than additive. He produced striations by using a stiff brush with thinned pigments, so that the grainy texture of the canvas showed through. He emphasized some areas by dry brushing another color or value over the thin paint or, more often, by wiping out an area with a cloth. These are effects that might occur in the initial stages of any painting, but they are normally eliminated in later phases of the process. Carrière's insight was to recognize the potential for expression and the esthetic merit of these unintended, accidental, or traditionally undesirable results.

Sketch of a Man Writing of about 1887 (Fig. 36)[134] combines a variety of techniques: thick, pasty pigments in the lower section; an oil wash through which the canvas texture is visible for the dark plane that describes the man; and thinned paint applied with a stiff brush to create textural striations for the rear plane. The fingers of the right hand and several other shapes were established by scratching the wet paint, a technique the artist also used for his signature at the upper left. The composition is determined not by line, shape, and color but by differences of technique and texture. The Park (Fig. 37), a landscape of about 1890–95, was produced almost entirely by working or applying the paint with a stiff brush and, to lesser degrees, by wiping and scratching. While he remained committed to his images, Carrière was acutely conscious of process and technique, which became an integral part of his content.

Carrière's interest in the animation of the surface (much of his work can be viewed as compositions of subtle rhythmic patterns moving fluidly across the texture of the canvas) is related to the emphatic surface movement in the works of Vincent van Gogh. Although the highly expressive charge of van Gogh's rich palette and heavy impasto is markedly different from the quiet poetry of Carrière's wiped and scratched monochrome washes, both artists applied paint in a way that set the surface in motion. And although Carrière's forms are vaporous and indistinct, they often have a strong sense of two-dimensional design. Through contrasts of value and texture, as in Woman in Profile of about 1895 (Fig. 38), Carrière achieved effects similar to those other artists, such as his friend Paul Gauguin, produced with bold colors and flat line.

Carrière's art does not mime nature but rather takes nature as its motif recording not the material world but the immaterial essence or spirit of nature. His renunciation of color (except brown), rational space (undefinable in his enveloping mist), and natural light (irrelevant in a style based on evoking the realm of spiritual essences) occurred during the period when he was spending more and more time with Symbolist writers and poets. Symbolism transformed Carrière's art, which was hailed by the critics

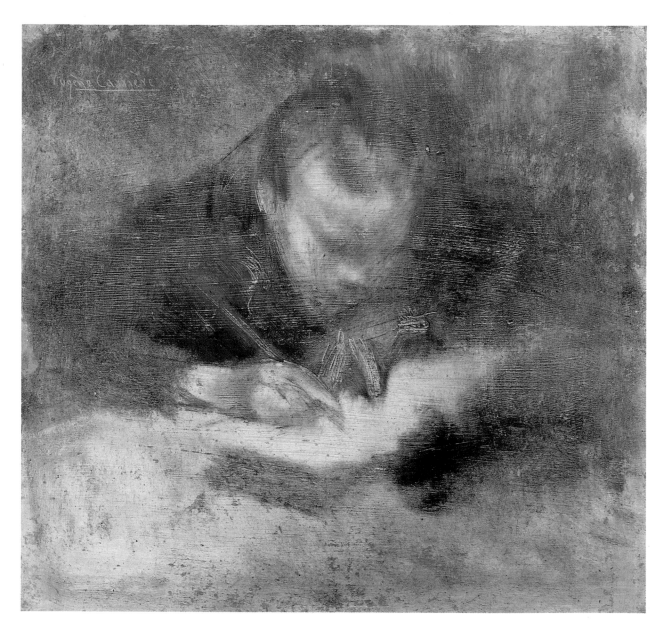

36.

Sketch of a Man Writing

c. 1887

Oil on canvas, 31¾ × 34 in.

Detroit Institute of Arts, Founders Society

37.

The Park

c. 1890–95

Oil on canvas, 12 × 15½ in.

Museum of Art, Rhode Island School of Design,

Providence

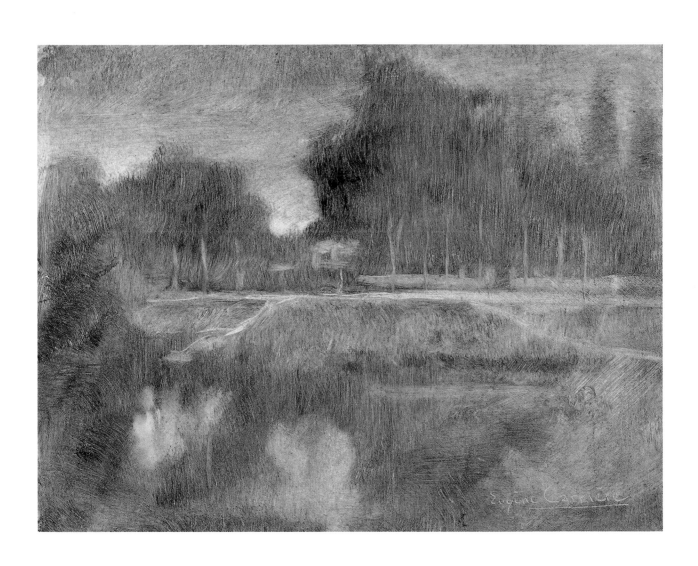

38.

Woman in Profile

c. 1895

Oil on canvas, 16⅛ × 13⅛ in.

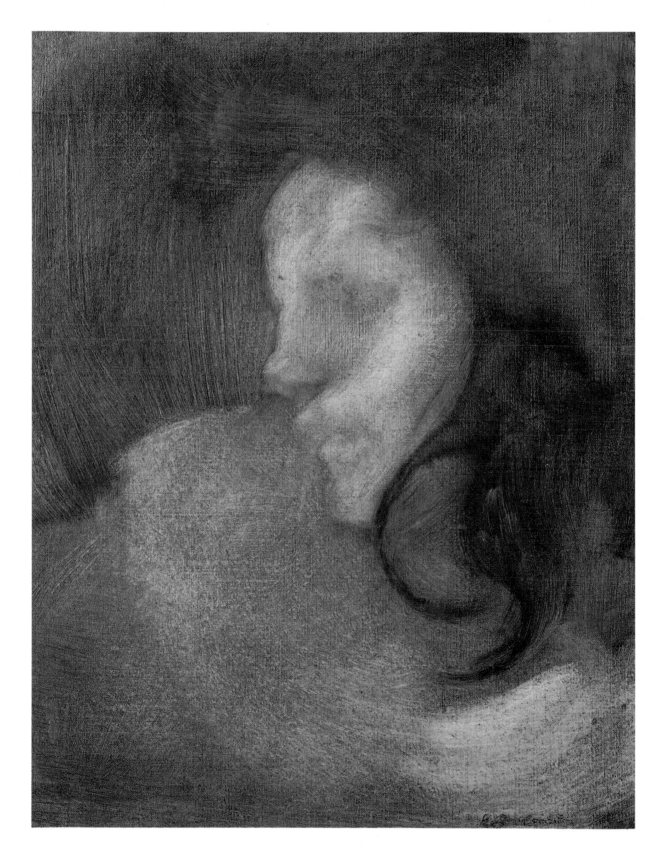

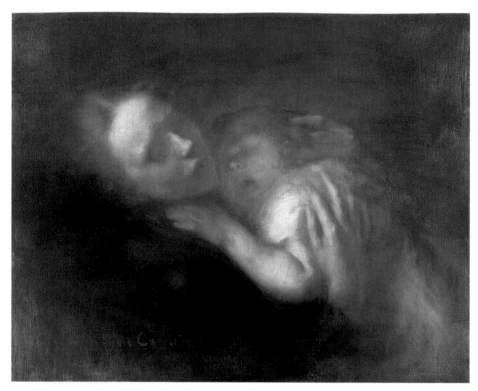

39.

Mother and Child

c. 1889

Oil on canvas, 19 × 23½ in.

Philadelphia Museum of Art

John G. Johnson Collection

as a pioneering visualization of Symbolist thought.

 Mother and Child (Fig. 39) of about 1889[135] typifies the evolution of Carrière's art in the late 1880s. In his *Art poétique*, written in 1874 but not published until 1882, Paul Verlaine had proposed a new philosophy of Symbolist poetry:

> **No Color, nothing but nuance!**
>
> **Oh! the nuance alone betroths**
>
> **The dream to the dream and the flute to the horn!**[136]

Stéphane Mallarmé stated the same idea more directly in 1891: "To *name* an object is to suppress three-quarters of the poem's joy, which comes from the pleasure of guessing little by little; to *suggest it, that is the dream. It is the perfect practice* of this mystery that constitutes symbol: to evoke an object little by little to reveal a state of soul, or, inversely, to choose an object and extract from it a state of soul, by a series of decipherings."[137]

 In his *Amoureux d'art*, published in 1888, the critic Jean Dolent, an avid collector of Carrière's work, described his art as "realities having the magic of a dream."[138] The same phrase is also the title of the etching by Carrière that Dolent used in his book. *Realities Having the Magic of a Dream* (Fig. 40),[139] an image of a reclining mother holding an infant to her breast, is compositionally similar to *Mother and Child*, except that here the mother holds her sleeping infant to her shoulder. The title of the engraving could just as easily describe *Mother and Child*, and indeed all of Carrière's Maternités from the late 1880s on.

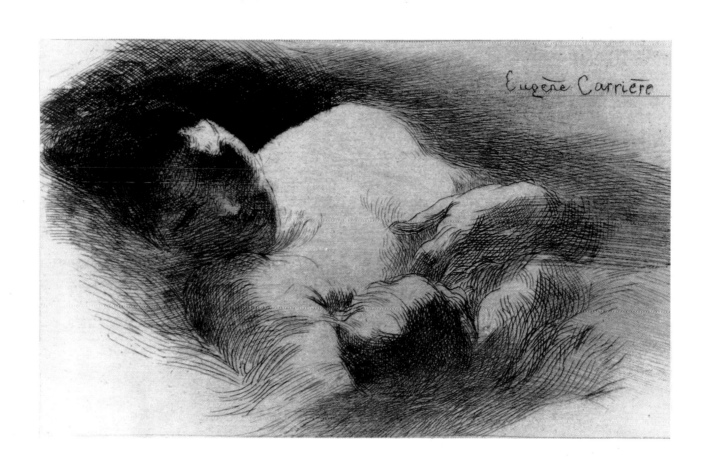

40.

Realities Having the Magic of a Dream

1888

Etching, $3\frac{3}{8} \times 5\frac{1}{2}$ in.

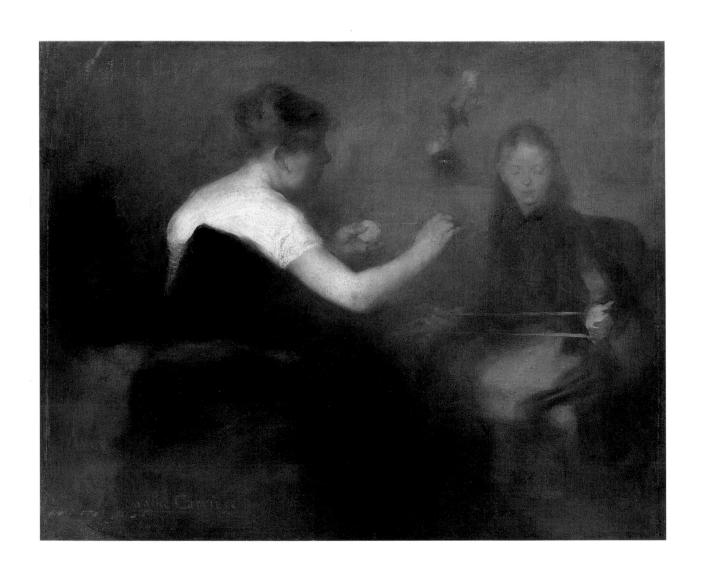

41.

Winding Wool (The Spinners)

1887

Oil on canvas, 46 × 38 in.

Tate Gallery, London

All that is discernible of the accessories or environment in Carrière's Salon painting *Winding Wool (The Spinners)* of 1887 (Fig. 41)[140] is the barest indication of the armchair on which the girl sits and a vase of flowers on an indistinct surface. Despite the anecdotal title, the real theme is the emotional and physical bond between mother and daughter. Carrière came to view his family as symbolizing the family of all mankind. Téodor de Wyzewa wrote in 1886 that "everything is a symbol, every molecule is swollen with the universe; every image is the microcosm of nature as a whole. The play of clouds speaks to the poet of the revolution of atoms, conflicts of societies, and the clash of passions. Are not all beings creations like our souls, sprung from the same laws, called to life by the same design?"[141] Carrière echoed this idea in the preface to the catalogue of his show at the Salon de l'Art Nouveau in 1896: "I see other men in me and I find myself in them; what impassions me is dear to them."[142]

The mystic Edouard Schuré took the concept of universal unity a step further when he declared in 1889 that "the spirit is the only reality. Matter is but its inferior expression, changing, ephemeral, its dynamism in space and time. . . . Creation is eternal and continues like life."[143] Carrière, too, contemplated the material world to discover within it the underlying forces of life. In the same preface, the first published statement of his ideas, he went on to say, "A love of the external forms of nature is the means of understanding nature has imposed on me. I do not know if reality eludes the mind, a gesture being a visible wish! I have always felt them to be united."

Because he perceived all mankind in each individual he painted, it was not necessary for Carrière to go outside his beloved family for models. *Portrait of Jean-René Carrière* (Fig. 42) was to Carrière not only an image of his infant son but also a portrait of life itself. The lack of individualization in his figures that began in the late 1880s coincided with the maturing of his philosophy. When Jean-René was born in 1888 he was a treasured addition to the family, especially as the first son, Eugène Léon, had died in 1885 at the age of four. This portrait and *Newborn with Bonnet* (Fig. 6), are probably close in date, though the oil may have been done as late as 1892. Jean-René is recorded as a spiritual presence. The paint and its application have been given such importance that Carrière was clearly attempting to record more than mere visual appearance. The animation of the thinned pigments applied with a stiff brush, leaving the striations and the texture of the canvas visible, may symbolize the forces that coalesce in the baby's head, which rests on the ruffled collar as if disembodied, seeming to emerge from the undifferentiated environment around it.

In 1886 Carrière commented to Dolent that "a painting is the logical development of light."[144] Light was the first element of Biblical creation. As the source of all energy and life, light penetrated the dark primal flux to bring forth life. Carrière may have been thinking of this first light when he worked with his dark, enveloping

42.

Portrait of Jean-René Carrière

c. 1890–92

Oil on canvas, 12 × 9⅝ in.

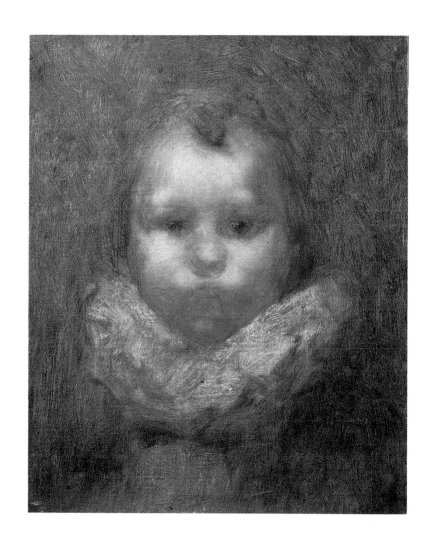

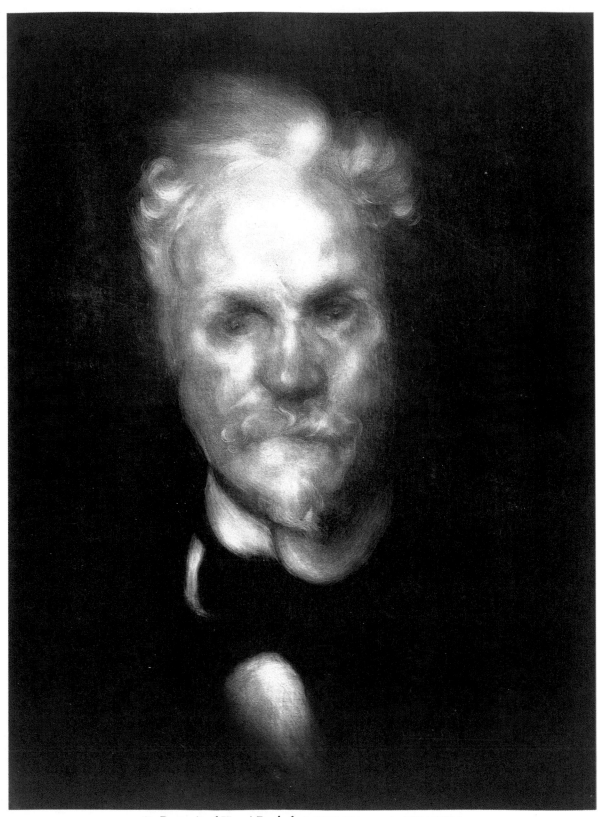

43. *Portrait of Henri Rochefort,* 1896. Lithograph, 26⅝ × 19⅝ in.

atmosphere. He described his palette not as brown but as "earth-toned."[145] The earth tones could symbolize amorphous matter prior to the generation of life through the activating forces of spiritual energy. To Carrière the act of painting, the bringing forth of a image from the canvas, was akin to God's creation of Adam from the earth. Léon d'Agenais believed that creation stories, including the Bible's, contributed to Carrière's philosophy,[146] though Carrière himself refrained from any reference either to religion in general or to a divine creator. *Meditation* of about 1890–95 (Fig. 17) is a visual record of an image coming into being; the isolated, pensive figure is a spiritual presence that grows out of the surrounding energy. For Carrière the process of painting had become, technically and symbolically, a process of creation.

Starting in the early 1890s Carrière's social and intellectual contacts with Symbolist writers began to be more directly documented in his work. In 1890 he painted his now famous *Portrait of Verlaine* (Fig. 7), a photo-lithograph of which served as the frontispiece for the poet's *Choix de poésies*, published in 1891. According to their mutual friend Charles Morice, who arranged the sitting for this portrait, Carrière was well prepared to meet Verlaine, having read and meditated on the poet's writings.[147] Verlaine himself may have requested that Carrière do his portrait in anticipation of its being used for his frontispiece. Verlaine wrote a poem, "A Eugène Carrière," as a gesture of appreciation. The poem, which appears in *Choix de poésies*, is the poet's analysis of his own likeness in Carrière's portrait.[148]

44.

Portrait of Henri Rochefort

c. 1894

Oil on canvas, 24 × 20⅞ in.

Musée de Strasbourg

Because almost all of Carrière's prints are precisely datable, they are important guideposts for the paintings, most of which lack dates. *Woman in Profile* (Fig. 38) bears a striking resemblance to *Nelly Carrière*, a lithograph of 1895.[149] Except that the image in the lithograph was reversed when it was printed, the two heads are nearly identical. The woman's head floats, disembodied, like an indistinct apparition. Her expression in both works is of one deep in reverie, dream, or trance—states of mind that Symbolist artists and writers explored in the belief that they led to a new and higher awareness of spiritual truths.

Carrière transferred his innovative painting techniques to the medium of lithography. He used a rubbing crayon to create rich, misty darks. Smudged, grainy effects were attained by rubbing the surface of the stone with a cloth that had been permeated with the crayon. He would also wipe the crayoned surface of the stone or

scratch into it. Comparisons of related examples in both mediums show his lithographs to be more visually dramatic than his oils, which have a quiet and mysterious tone. This is best seen in the lithographic and oil portraits of Henri Rochefort (Figs. 43, 44).[150] The painting, inscribed *Henri Rochefort — sincère hommage*, shows Rochefort's head and white collar emerging from a dark unformed environment rendered with slight striations in a textured earth-toned ground. The face is clearly expressive, its expression focused in the eyes, the windows of the soul. The painting preceded and was the basis for the lithograph, in which Rochefort's image is of course reversed. The middle through light values of the oil are exaggerated to create a white and black contrast with no range of subtle values to capture the sitter's expression. Although it lacks the psychological or spiritual intensity of the painting, the print has a visual drama that is equally insistent.

The theater, with its suspension of reality, naturally interested Carrière. In 1886 he started working on *Le Théâtre de Belleville* (Fig. 45),[151] a large painting approximately seven by nine feet intended for Paul Gallimard, the publisher and collector. Edmond de Goncourt, who occasionally visited Carrière's studio, briefly describes the painting in the entry he made in his journal for June 5, 1890. His entry for December 20 the same year relates that at the dinner Gallimard hosted to celebrate the publication of de Goncourt's *Germinie Lacerteux*, Carrière showed de Goncourt a list of Parisian themes he wanted to paint. One was "the parade of the Parisian crowd," people passing each other in the street. Another was "the thirsty around the Théâtre de Belleville," a number of people in shirtsleeves offering beer and refreshments to the crowd leaving the theater.[152] Possibly Carrière was thinking of *Le Théâtre de Belleville* as part of a series of three related works. *The Passerby* of 1896, a large oil (7'6" × 4'3") depicting three women walking on the street, may be his intended "parade of the Parisian crowd."[153] He seems never to have painted "the thirsty around the Théâtre de Belleville."

In his journal entry for January 4, 1894, de Goncourt noted that Carrière was working feverishly on *Le Théâtre de Belleville*, which he hoped to complete "for the exposition," presumably the Salon of 1894.[154] Apparently he was unable to finish the

45.

Le Théâtre de Belleville
1886-95
Oil on canvas, 88 × 196 in.
Musée Rodin, Paris (P7281)
Photographed by Denis Bernard

painting until later that year or the beginning of 1895, when it was exhibited at the Salon.[155]

Le Théâtre de Belleville is a view of the spectators in a balcony of a working-class theater. There is no indication of the stage. Carrière focused on the audience and its reaction, rather than the visual spectacle of the performance. (Honoré Daumier, the master of the theme of the modern urban crowd, had a similar interest in the audience, as is seen in his painting The Drama.) Carrière's atmosphere and softened focus unite the many figures scattered across the wide canvas. Though the poses are quite varied, he captured the communal reaction of a mass of nameless spectators bound emotionally and spiritually in the experience of watching a performance. There is a sense of silence, as though this were a religious occasion.

It was Dolent, whom he met in 1886, who stimulated Carrière's interest in the theater in general and in the Théâtre de Belleville in particular. But that year Stéphane Mallarmé also wrote a series of nine articles, entitled "Notes on the Theater," that appeared in the monthly issues of La revue indépendante from November 1886 to July 1887.[156] The articles were a virtual manifesto of the Symbolist theater. Mallarmé proposed that the stage be detheatricalized, that props, settings, costumes, and even actors' characterizations be eliminated in favor of blank recitation of lines. He wanted drama to be a mysterious experience, a sacred rite that spiritually united the audience in the discovery of hidden meaning: the spiritual response the play elicited in the audience, and not the performance itself, was what mattered. In this context the softened focus and atmospheric effects Carrière used to fuse his many figures may have had a second purpose. He may have had in mind Mallarmé's dictum that "everything sacred and that wishes to remain sacred is enveloped in mystery."[157]

Like the Intimists Pierre Bonnard and Edouard Vuillard, Carrière explored a quiet poetic world in which a mood or feeling is evoked and technique complements representation. This is seen in his Woman in an Interior of about 1898 (Fig. 46), which is as much a statement of paint, canvas, and textures as it is an image of a woman in an interior. The largest shape, the languorous woman, was laid in with a stiff brush, creating undulating patterns that echo the pose of the figure. The lightest shape, in the center of the composition, is logically in the background because it is overlapped by the shape of the figure, but it is pulled forward from the darker areas around it. Except for a few spontaneous light strokes at the middle right that defy interpretation and the upper portion of the shape of the figure, the entire upper two-thirds of the painting received a second, darker oil wash. On top of this the darkest pigments were added, primarily at the

46.

Woman in an Interior

c. 1898

Oil on canvas, 11⅛ × 6¾ in.

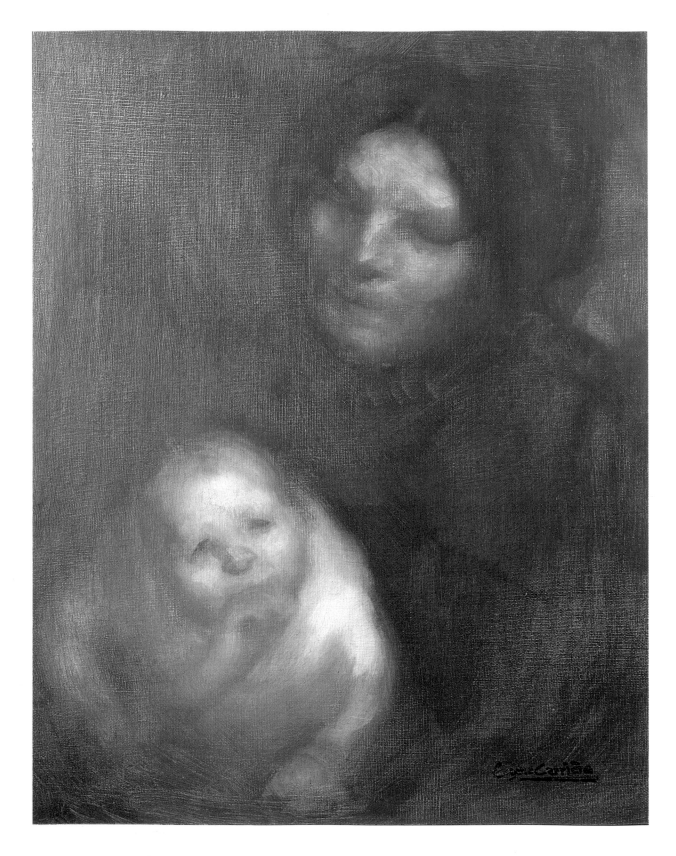

right, without obliterating either the canvas's texture or the striations left by the brush. The composition is basically an area of darker canvas texture above and a lighter one below that contain a fluid shape that either starts or ends at the light circular shape of the head, with a very prominent light rectangular shape just above center. Very little is strictly reproduced. The woman appears to be seated, though no piece of furniture is even suggested. The character of her clothing, her facial features, and her expression are undefined. The interior, the area above and behind the figure, is indicated merely by shapes, textures, and values. Carrière's innovative manipulation of his medium served to create an interior that is poetic space and a figure that is spirit.

With the birth in 1899 of his last child, Arsène, Carrière resumed his interest in the theme of mother and child. At the time, many critics discerned a religious tone in Carrière's work, particularly in the Maternités, which were thought of as secularized Madonnas. In essence, he saw the relation between a mother and her child as symbolic of the continuity and regeneration of life. "Time doesn't change the nature of beings," he said in a letter of December 1904, "and the modern Woman always appears to us as the symbol of creation."[158]

In *Mother and Child* of about 1899 (Fig. 47) the infant does not appear to be physically supported. In place of the mother's arms, faint arcing striations embrace the child, evoking spiritual and emotional bonds. The dark oval shape of the mother's face and hair is echoed at the opposite corner by the child clothed in white. The two figures are opposite in value but similar in shape and size, and the infant's extended arm repeats in reversed value the line of the mother's arm. The placement of these two oval shapes on a uniform dimensionless background recalls Carrière's *The Bride* (also known as *First Communion*) of about 1896 (Fig. 48), which conforms to a large oval shape containing other ovals.[159] The girl gowned in white floats in a dark environment, anticipating the image of the disembodied *Mother and Child*.

Portrait of a Woman (Fig. 49), a pastel of about 1898–1905, is interesting not only for its medium but also for its palette of blue, red, and pink. For one who had edited color from his work, Carrière could on rare occasions still employ it like a master, even in a medium relatively foreign to him. No other pastels by Carrière are known. He apparently exhibited one in 1894 at the Salon of the Société Nationale des Beaux-Arts, but unfortunately the one critic who mentions it gives neither a title nor a description.[160] This may be a portrait of Carrière's daughter Elise, who was born in 1878 and so would have been in her twenties, about the age of this model, in the late 1890s and early 1900s. The woman's features and hairstyle are similar to those in Carrière's other portraits of Elise of this period. The dressing gown she wears is unexpected, not only because Carrière had so diminished the importance of accessories after the late 1880s but also because of its exotic orientalism. Orientalism was very much in vogue in the second half

47.

Mother and Child

c. 1899

Oil on canvas, 16⅛ × 13 in.

Collection of Peter J. Tanous, New York

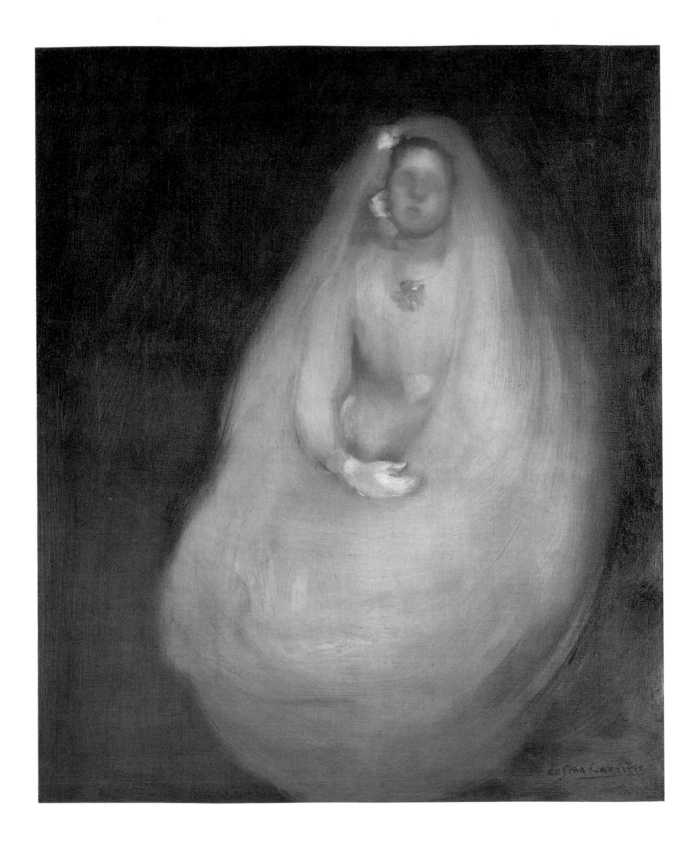

48.

The Bride
(First Communion)

1896

Oil on canvas, 25¾ × 21 in.

Metropolitan Museum of
Art, New York

Gift of Chester Dale, 1963

(63.138.5)

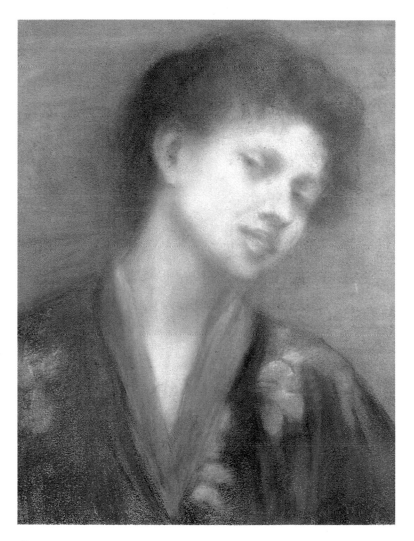

49.

Portrait of a Woman

c. 1898–1905

Pastel on paper, 18 × 13 in.

of the nineteenth century, and Carrière would have been frequently exposed to it. Yet it seems he flirted with it only this once. The soft colors, the languorous sensuality, and the orientalism of *Portrait of a Woman* may have been derived from the female portraits of James McNeil Whistler. Whistler's late work, with its hazy, dreamlike quality, must certainly have interested Carrière. The two men may have first known of each other through their mutual friends Mallarmé and Rodin. Whistler's correspondence with Mallarmé confirms that he had known Carrière's work for years prior to April 1898, when Carrière showed nine graphic works at the first exhibition of the Société Internationale, of which Whistler was president, in London.[161] And it would have been easy for Carrière to know Whistler's paintings, as he showed as frequently in Paris as in London.

In any case, one can conclude from the pastel that Carrière had not entirely abandoned his youthful experiments with different styles. About the same time he produced an even more surprising stylistic deviation, *Mont Valerien* (c. 1898), a landscape in the manner of Paul Cézanne.[162]

The Lessons of Nature

Sometime before his final departure for the South Pacific in the spring of 1895, Paul Gauguin told Jean Dolent: "No one knows Carrière's landscapes, and already they are imitated."[163] Carrière's interest in landscape painting was little known until 1901, when he had an exhibition at the Galerie Bernheim-Jeune that included twenty-seven landscapes.[164] His landscapes, none of which are dated, are still often overlooked. Although Gauguin does not name any imitators, his statement proves that Carrière had begun to paint landscapes by 1895. It has generally been thought that Carrière started to work extensively with this theme late in his career, possibly in 1896 when the Carrière family spent their first winter in the south of France because of Mme. Carrière's delicate health.[165] During the winters of 1896–97, 1898–99, and 1901–2 the Carrière family resided at the Villa Saint-Pierre on the boulevard d'Alsace-Lorraine in Pau.[166] They chose Pau, in the foothills of the Pyrenees, not only for its weather but also because several of their friends had already started wintering there. Arthur Fontaine, André Gide, and Francis Jammes had undoubtedly spoken well of the area and encouraged the Carrière family to join them. Carrière's interest in landscape painting could have begun as early as 1893, however, when he met Rodin and Mme. Ménard-Dorian on the Isle of Guernsey.[167] Carrière had first traveled alone through Brittany and Normandy (both areas were inexpensive at the time and popular with artists – Boudin and the Impressionists had frequented the Normandy coast; Gauguin preferred Brittany), and he may have spent those two weeks painting. His *Landscape with Calvary*, now at the Musée d'Orsay in Paris, might have been painted then, after the roadside devotional images characteristic of the Breton countryside.[168] There were numerous other occasions on which Carrière had the opportunity to explore the landscape. He and his wife and

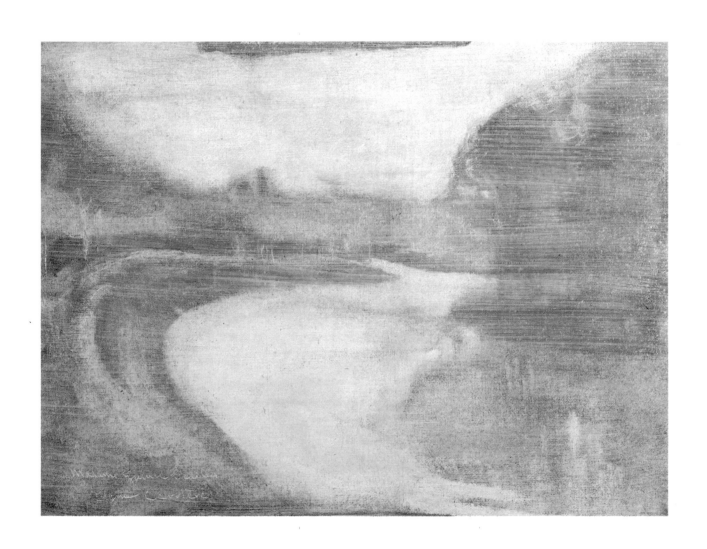

50.

Landscape Dedicated to Mme. Gabriel Séailles

c. 1893

Oil on board, 10½ × 13¾ in.

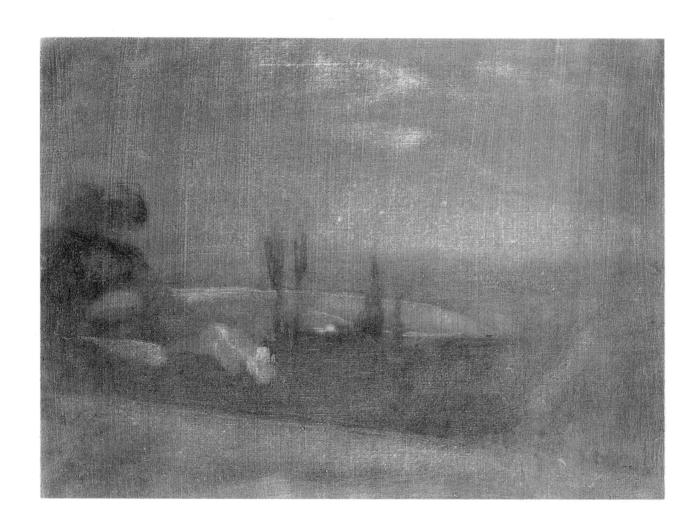

51.

The Plain

c. 1893

Oil on canvas, 12 × 16 in.

several friends vacationed in Bagnolles de l'Orme in June 1901, after which he visited the Channel Coast on his own.[169] Though they normally summered at their home at Parc Saint-Maur in Val-de-Marne, during the summer of 1904 the Carrières visited Saint-Valéry-sur-Somme. Carrière also made a trip to Spain with Louis-Henri Devillez in the summer of 1897,[170] and he traveled to Italy in February 1904 with Mme. Carrière and their daughter Nelly.[171]

Landscape Dedicated to Mme. Gabriel Séailles (Fig. 50) may have been done in 1893.[172] In a letter he wrote from Brittany to Gabriel Séailles on August 2, 1893, Carrière said that his wife was going to respond to Mme. Séailles's charming letter; he may have given Mme. Séailles the landscape that year. In this painting the pigments were thinned almost to the consistency of a glaze; some areas were rubbed out, and others—the tree trunks, the signature, and the dedication—were scratched while wet. That the range of effects, textures, and striations were not intended to capture natural appearances is further underlined by the absence of natural colors. Ironically, Carrière expanded his artistic vision to landscapes only after he had virtually eliminated all reference in his work to traditional concepts of illusionistic space and naturalistic environment.

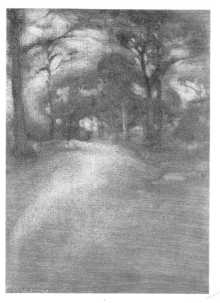

52.

Under the Trees

c. 1900–1905

Oil on canvas, 15⅞ × 11⅞ in.

The undulating lines and arabesques that became so prominent in Carrière's work during the 1890s tie him to Gauguin, the Nabis, and Art Nouveau. The arabesque was thought to be a line of life and energy. Carrière adopted it as a symbol of the pervasive forces in animate and inanimate nature, the spiritual energies that activate all matter. In his landscapes, as in his figures, he sought to capture not particular appearance but underlying animating principles: the image of a human face and a landscape were synonymous to him. "Carrière said to me one day," Séailles recounted in an article published in the *Revue de Paris* in 1899,

In Nature forms are harmonious, of the same family, expressions of the same idea that little by little grow stronger and clearer. Returning from Saint-Maur some time ago, I looked out the windows at the landscape speeding by, and I admired the undulation of the hills, to which the curves of the foliage were married; I turned around, and in front of me I saw a woman with a proud and pure mouth and in the mouth was clearly repeated all that I had just seen and admired. There is even a hierarchy of forms which explain one another; in nature, nothing is isolated from its natural sphere because everything is related, the hill and the plain, the tree, the earth and man. Likewise, a beautiful woman appears in a beautiful landscape, you see only her, but in her you see again all the rest.[173]

Séailles spoke of a series of drawings Carrière did in which natural forms like flowers or fruit coalesce into the human form.[174] Unfortunately, these sketches seem not to have survived.

If some of Carrière's figures are amorphous to the point almost of dissolving into his famous mist, *The Plain*, *Under the Trees*, and *Tormented Landscape* (Figs. 51–53) are little more than intimations of landscapes in which the image hovers between emergence and disappearance. In *The Plain*, painted about 1893, the major planes are established by transitions of value that are in fact relative intensities of the single brown hue. The shape of the light bottom plane of the foreground is echoed by the pale area just above the horizon, and the moving puff of cloud in the middle of the sky is repeated in the similarly shaped light area just below the middle of the horizon. While they establish a parallel balance between the upper and lower halves of the composition, these paired areas may also symbolize a correspondence of the material (the terrain) and the immaterial (the sky).

Carrière's compositions were often unorthodox, and this is also the case in *Under the Trees*, of about 1900–1905. It is unusual for a landscape to have an unbroken foreground that occupies more than half the painting. *Under the Trees* is composed of a very large foreground and a distant background, with an implied middle ground. Except for the trees to the far left and right and the diagonal band of light on the road, there are no shapes in the foreground, where value and texture are subject to only the subtlest modulations. The implied middle ground, the obscured background, and the trees through which occasional glimpses of sky appear occupy the smaller upper portion of the composition. The perspective effect of lines converging to a vanishing point is absent here, even though the space is rationally understood as moving back from the viewer.

If *Under the Trees* is examined in terms of patterns of light and dark, rather than on the basis of spatial planes, the painting's dominant configuration becomes an arabesque. Starting at the lower left edge, a path of light rises diagonally toward the center and then turns back, ending just to the left of the middle of the painting. In tandem with this an undulating upward-sweeping shape at the horizon initially moves left, reverses direction, and then reverses again. Moving through the break at the background plane, these two sinuous shapes of lighter value combine to form an arabesque. Striations in the paint produce an effect of swirling undulation in both light and dark areas of the upper portion. Striations broken only by the path of light start at the bottom, cross the canvas, and become animated near the top of the foreground plane. The tranquility of the base of the painting yields to the animation of the upper portion. The viewer is visually led not so much back as up into space, to witness the vitality of nature.

From Pau on December 2, 1901, Carrière wrote to his friend Raymond Bonheur:

We have rambled about the hills and slopes. I am profoundly aware of the eternal meaning of these things that we pass so quickly. It is comforting to me to think that

all this is old and that we are ephemeral passersby, and that it will always endure
and that others after us will say the same things. I have also found great joy here, I
cannot tire of looking, of delighting in my eyes. Waves of vitality overwhelm me. I
feel as if I am living abundantly, and I become one in spirit with this atmosphere of
ecstasy born of serene logic: these beautiful undulations of terrain, these beautiful
trees which embroider the moving heavens with living arabesques, the lovely
supple carpet of deep, dark green, the sound of waters, their transparency, the
speed with which they vanish and escape from us with long trails in recurring
patterns, as we ourselves come and disappear, leaving the same wakes of the
departed to the newly arrived.[175]

Art Nouveau was based on the study of natural forms and the undulating line
was its symbol of growing forces, evoking young plants emerging from the ground and
starting to unfold or vines and tendrils coiling and reaching out. For Carrière this sinuous
animated and animating line expressed the rhythmic patterns of the ubiquitous force of
nature. In "Visionary Man of Reality," the speech he gave in March 1901 at the Musée
d'Histoire Naturelle in Paris, Carrière expounded his philosophy of the continuity of life
as it is revealed in the forms of nature:

Man's imagination is exalted by contact with Nature. Visionary of the real, he
undertakes his own discovery.

Our imaginative power lies in our incessant effort to realize our
relationship with Nature, the place we hold there, the significance of our arrival
among the crowd of beings. – Where would this imagination find the material
upon which to exercise itself if not before the infinitely varied form of the *Skeleton*,
from which it evokes life?[176]

Carrière viewed the skeletons on display in the Gallery of Anatomy, where he delivered
his speech, as sculptural forms, and he interpreted their shapes and patterns in the light of
Symbolist philosophy. His descriptions of them are more poetic than scientific:

The skeleton is the material proof of the continuity of forms, of earthly logic.

The vertebrae of the Rhinoceros, shaped like thick-leaved plants, are in
harmony with the abundant earth where he reigns, laden with thick vegetation
which nourishes his bulk. He is the image in motion of the soil that produced
him.[177]

A number of writers speculated on various scientific theses that might have
influenced Carrière's thinking. In his monograph on the artist Elie Faure took the position
that Carrière's "evolutionist" theory developed independently and that neither Jean
Lamarck nor Charles Darwin had inspired him.[178] Faure noted, however, that Frédéric
Houssay, a philosopher of natural sciences and a contemporary of Carrière's, proposed a
theory that is similar to Carrière's concept of universal unity:

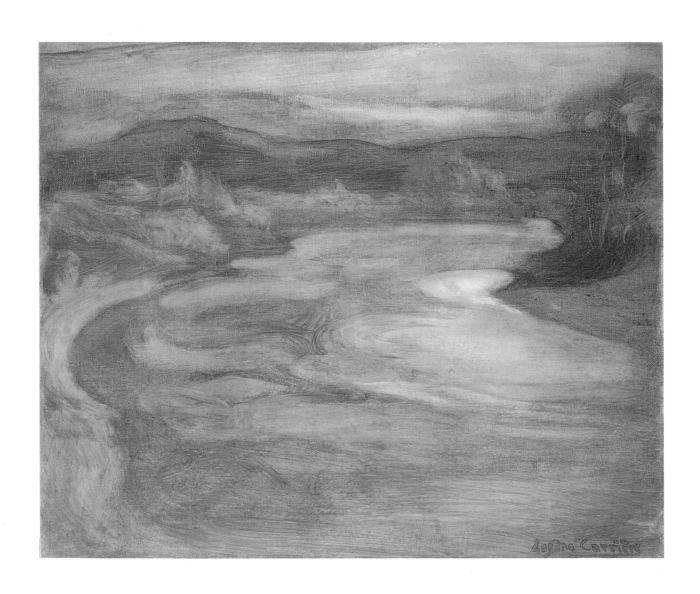

53.

Tormented Landscape

c. 1900–1905

Oil on canvas, 15¾ × 18⅞ in.

Nothing is completely distinct. As a point of reference, let us begin with atmospheric air. Not only does it encircle and bathe what we call bodies, but it penetrates them, dissolves there, combines there, and they blend with it. . . . There is not only contiguity, but continuity of substance between the air and these beings, because oxygen is incessantly incorporated in their matter and then leaves it, and if one follows a small amount of gas in the lungs, in the blood, in the organs, at no one moment could one say with certainty whether it is still air or whether it is already animal tissue. . . .

The vision of continuity we have just sketched certain aspects of is far from being paradoxical, far also from being purely intellectual and, like scholars, artists with a penetrating eye have known this. Do not painters seek to assemble creatures in the landscape and combine them in a gangue of atmosphere? And some of them, like Carrière, whose genius is tormented by this sensation, do they not paint so that everything is connected to everything?[179]

Houssay wrote this after Carrière's ideas had matured, and he did not include in his theory what would have been to Carrière a crucial element: a universal animating force.

Léon d'Agenais mentioned the theories of Pierre Curie and Wilhelm Röntgen, which were published late in Carrière's career, as possible sources of influence.[180] But although their ideas may have confirmed Carrière's philosophy, they did not contribute to it. Richard Teller Hirsch proposed Buffon, Linnaeus, and "the entire, creative, brilliant and groping tradition of naturalistic naturalists [that] might be termed a fin-de-siècle '*salade russe*' of scientific and philosophic hypotheses."[181] The source that most closely parallels Carrière's theories, however, is Lamarck's *Philosophie zoologique* of 1809, which was receiving increasing attention in the late nineteenth century.[182] Lamarck's theory that gelatinous or muscilaginous matter was activated by a vital principle that produced one aboriginal cell from which all plant and animal life evolved would undoubtedly have captured Carrière's imagination,

54.

The Route from Pau

c. 1896–1900

Oil on canvas, 14 × 18 in.

for it coincides with the Symbolist theory that all of nature, animate and inanimate, shares the same basic energy of life. The permeation of formless matter by an immaterial vital force is equivalent to the idea of the continuity and propagation of life that is the underlying premise in Carrière's art. Similarly, Lamarck's thesis that all life is related through a common ancestry may have inspired, or at least confirmed, Carrière's concept of the universal harmony of form and the continuity of life.

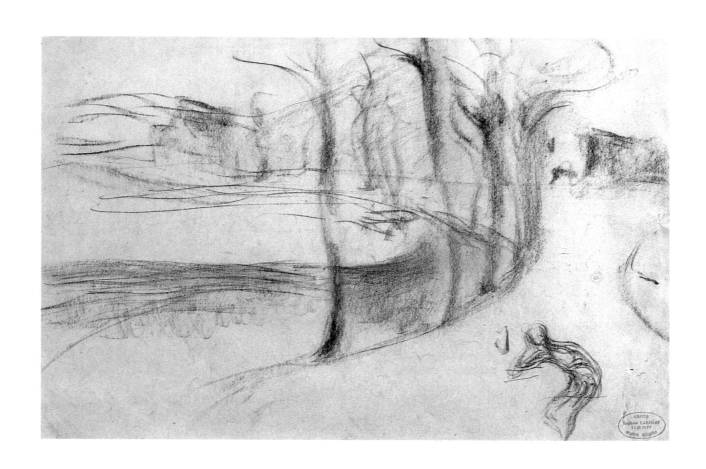

55

Landscape with Silhouette

c. 1900

Pencil on paper, 8⅜ × 13⅜ in.

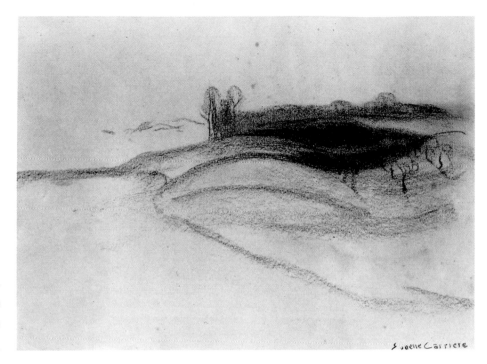

56.

Landscape

c. 1895–1900

Charcoal on paper, 9¼ × 11¾ in.

57.

Study for the Figure of Daudet

c. 1890

Pencil on paper, 7⅝ × 4⅞ in.

Art Institute of Chicago

Gift of Ivan Loiseau

(1967.234)

Odilon Redon's comments about his own art, that he "put the visible at the service of the invisible" and that his intention was "to transform human emotions into arabesques," seem equally applicable to the work of Carrière. Paintings such as *The Route from Pau* of about 1896–1900 (Fig. 54),[183] and especially *Tormented Landscape* of about 1900–1905 (Fig. 53) embody this principle of pervasive rhythmic energy. In *Tormented Landscape* linear animation dominates. The swirls and eddies in the water are repeated in the treatment of the banks bordering the flowing river. The undulating, organic configurations are comparable to areas of Edvard Munch's *The Cry* of 1893 or Paul Gauguin's *I raro te Oviri* (*Under the Pandanus*) of 1891. Although like Carrière these two artists employed the arabesque, their styles, techniques, and intent were markedly different. Carrière's search for energies or spiritual forces that animate our world is of a different spirit than either Munch's emblems of the irrational and subconscious quarters of the mind or Gauguin's explorations of the barbaric, the mythic, and the intuitive as paths to primal truths.

Rhythmically undulating lines of expressive energy are the trademark of Carrière's drawings. Carrière drew incessantly, recording his responses to the fleeting moments and gestures about him. A great number of his drawings have survived, few of which seem to have been done as preliminary studies for particular works. The vast majority of his drawings are unrelated to each other except in style and general theme (see Figs. 55–57). In some a gesture or motif is repeated on the same page in successive

attempts to capture or distill. More commonly, two or more thematically related motifs are juxtaposed in one sketch.

In his monograph *Eugène Carrière: Essai de biographie psychologique* Gabriel Séailles said that

to understand Carrière's drawing, it is necessary to have looked at his sketchbooks with gray covers, to have handled the loose sheets – announcements, handbills – which lie about on the studio table, crowd the drawers, accumulate in boxes, these "thinkers," as Watteau called them, these thinkers of the morning and of the evening, of all the hours of leisure study, in which he prepares the works that prolong his life in the images it creates. These innumerable sketches in black crayon, in red, are rapid notes that express his indefatigable passion of observation.[184]

58.

Portrait of a Young Girl

c. 1900

Oil on canvas, 16¼ × 13 in.

Landscape with Silhouette of about 1900 (Fig. 55) employs a variety of effects, from fine lines done with the point of a soft lead pencil to areas of grainy halftones laid in with the wide side of a soft carpenter's pencil. It is a masterpiece of spontaneity. Though the lines are Art Nouveau in character, the nervous energy in the landscape and the figure recalls the drawings of Daumier. The silhouetted figure shares the animation of the landscape and fills what would otherwise be a blank corner. The presence of this figure grounds the upward undulation of the trees whose branches reach into the sky, and it defines the road as a shape that flows down from the upper right to the entire base of the composition, where it too branches. In most landscapes such a movement of the road would convey a sense of spatial recession, but here the road functions as a fluid two-dimensional shape that counterbalances the opposing leftward motion. Like many of Carrière's drawings from the turn of the century, this was done in Conté crayon and charcoal, resulting in effects that recall the vaporous character of his oils and lithographs.

Through the Last Years

Mme. Carrière was the artist's primary model for two decades, but she was succeeded during the last years of her husband's life by her daughters. Her health was poor, and Carrière no doubt felt she could no longer stand the strains of modeling. Elise and, to a lesser degree, Nelly became his favorite models. *Portrait of a Young Girl* of about 1900 (Fig. 58) is one of a great number of portraits Carrière did of his children between 1900 and 1905. The girl appears to be an adolescent and therefore may be either Nelly (b. 1886) or Lucie (b. 1889). This painting is typical of Carrière's later family portraits, in which the figures are lost in thought, reverie, or in some instances what looks like trance. The young girl's calm expression and the pose of her hand were captured as telling signs of her soul.

As he did in a number of other paintings around the turn of the century, Carrière used gray for secondary highlights on the hand, the cheeks, and the chin in

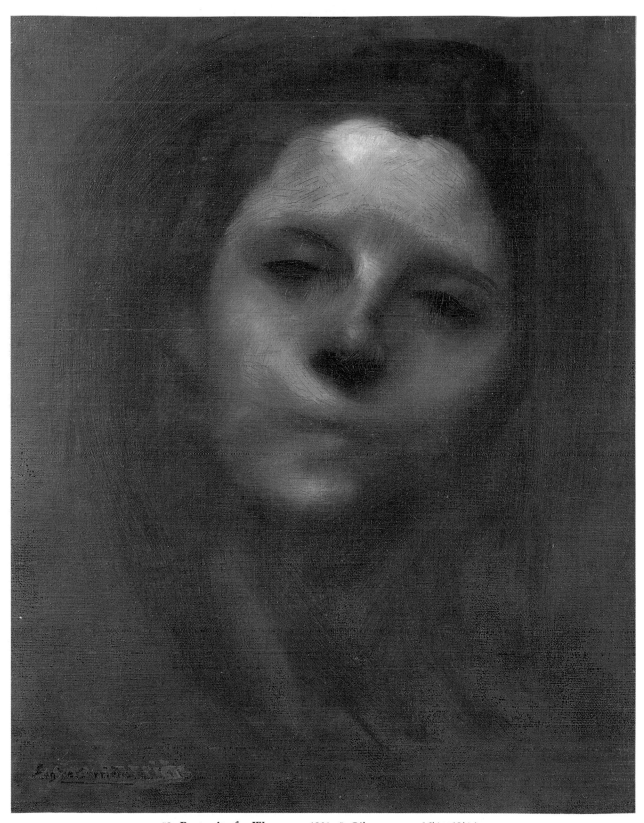

59. ***Portrait of a Woman***, c. 1901–5. Oil on canvas, 16½ × 12½ in.

60.

Portrait of a Woman Seated

1901

Oil on canvas, 24½ × 19¾ in.

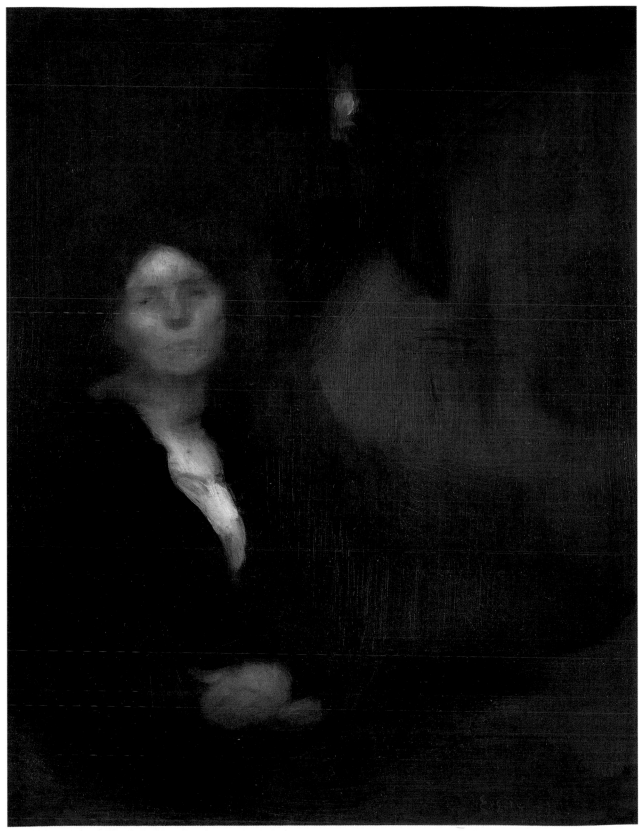

Portrait of a Young Girl. About this time he began occasionally to use gray to set off one or more areas against the rest of a painting. The effect was to isolate and subtly emphasize an object or figure. By 1901 he was producing a number of works entirely in gray. The gray was applied over brown underpainting, which shows through in passages where the gray paint is sufficiently thin or in tiny spots, often single pores of the canvas, not covered by the overpainting. Several of Carrière's late Salon pieces, such as *Portrait of M. and Mme. Gorodiche and Their Child*, now in the Musée Rodin,[185] are in monochromatic gray. In some of the gray paintings he used pink for flesh tones and applied other pale colors in a few areas. Yet even had he lived longer it is not likely that Carrière would have become a colorist. In his last works both the brown and gray palettes coexisted, and the brown remained dominant.

If Carrière's figures are thought of as existing on a plane somewhere between the physical and the spiritual, then gray — somewhere between white, or the presence of all colors and of light, and black, or the absence of all colors and of light — might well best symbolize this nebulous realm. What had started as a way to unobtrusively accentuate areas or elements became a means to establish the subtlest of nuances. This was related to a new emphasis in Carrière's philosophy. He adopted gray to visually reveal the harmony and oneness of the universe and the relation between the spiritual and the material, without the generative connotations of his brown palette. These ideas did not supplant his philosophy but, like his palettes, grew out of it.

Close analysis of *Portrait of a Woman* of about 1901–5 (Fig. 59) reveals numerous dots of red-brown showing through the top layer of gray paint, but in general the gray fills the pores of the canvas, eliminating its texture as well as obscuring the brushwork of the underpainting. Painterly virtuosity was shrouded in Carrière's gray paintings. The visual importance given the application was shifted to a smoother finish that emphasized subtle gradations of value. Figures corporealize from their undefined environment to form partially coalesced reliefs. Certainly it was this that prompted Rodin to comment: "Carrière is also a sculptor."[186] These effects recall the monochromatic brown Salon and commissioned pieces in which texture and painterly application are minimized. Carrière did not use his gray palette for all his late Salon and commissioned paintings. *Portrait of a Woman Seated* of 1901 (Fig. 60), for example, although it has the smooth finish that typifies his Salon and commissioned works, was done in his brown palette.

When *Portrait of a Woman Seated* was exhibited at the Société Nationale des Beaux-Arts Salon of 1901 it was titled simply *Portrait*.[187] Carrière's titles were often vague or barely descriptive; he wanted the paintings to speak for themselves, without titles that might inhibit or limit the viewer's reaction or interpretation. On many occasions he exhibited identifiable paintings, even at the Salon, with imprecise titles. For example, his

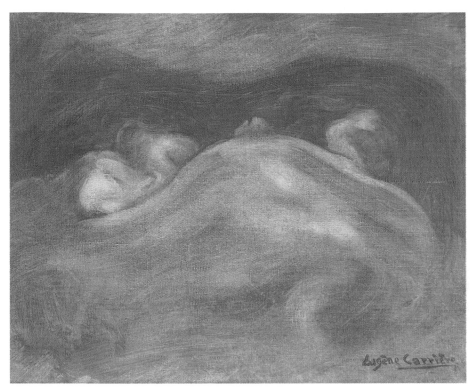

61.

Sleeping Children

c. 1903

Oil on canvas, 13 × 16⅛ in.

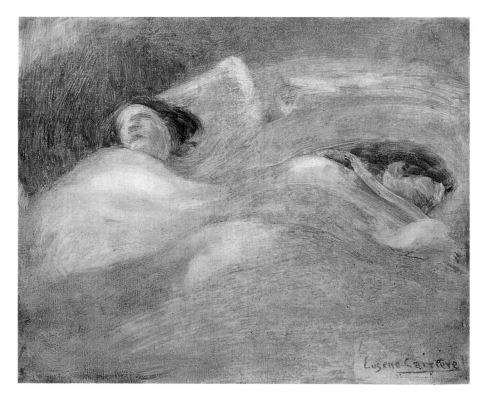

62.

The Two Sleeping Ones

c. 1900

Oil on canvas, 13 × 17¼ in.

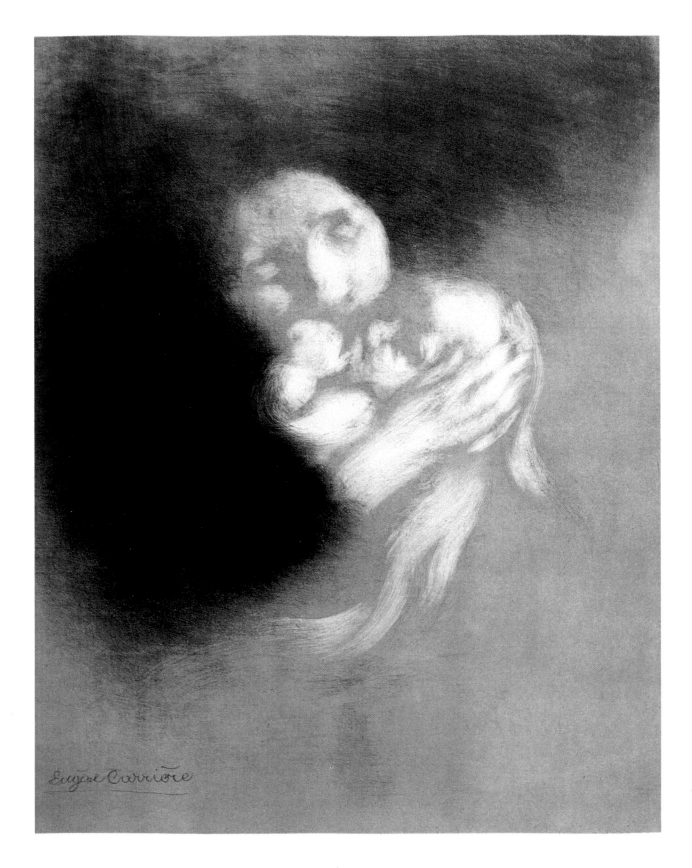

Portrait of Mme. Caplain and Her Daughter was shown at the Société Nationale des Beaux-Arts Salon of 1898 as *Portraits*.[188]

In *Portrait of a Woman Seated* Carrière concentrated on both the composition and the character of his sitter, who was probably his wife. The face and hands are blurred and the pose is only implied: the viewer's imagination must complete the image of the serene woman. In the entire painting the only area that has a sense of solidity is the white blouse visible through the opening in the front of the woman's dress. She materializes from the environment, coming into focus at her center or, conversely, she dissolves from her center into the dark. Though small, the figure is not a subordinate element. The composition has an intuited sense of balance. At the center top of the painting is a light vertical shape. Beneath this are two basic shapes—a large, dark brown, slightly textured shape that contains the figure, and a smaller shape of equal interest, with its ocher coloring and pronounced texture. The meeting of these two shapes is an animated arabesque. The composition is structured to suggest the dichotomy of matter and spirit, the dark and the light, and the energy—life—that is born of their interaction.

To Carrière any object or scene was a microscopic expression of the infinite macrocosm. If an image could be interpreted in more than one way, so much the better. Without their titles *Sleeping Children* of about 1903 and *The Two Sleeping Ones* of about 1900 (Figs. 61, 62) could just as appropriately be seen as landscapes. From the 1880s to the early 1890s, and then again from the turn of the century to the end of his career, Carrière did many works that depict young children and their interaction. The gap between the first and second periods corresponds to the years between Lucie's birth and infancy and the birth of Arsène in 1899 and his first grandchild in 1904. At the time *Sleeping Children* was done Lucie would have been fourteen years old and Arsène four. The two children in the painting are separated in age by more than a few years—ten is certainly possible. Given Carrière's comment on the reflections of the harmonies of landscape in the face of a woman, he may also have observed the rhythms of a landscape in the images of Lucie and Arsène sleeping.

In 1900, or shortly before, Carrière was commissioned to do four panels for the Bridal Chamber of the city hall of the twelfth arrondissement of Paris. This ensemble is known as The Four Ages, but *The Mothers* of 1900 (Fig. 65), *The Fiancées* of 1904 (Fig. 67), *The Nativity* of 1905 (Fig. 70), and *The Old People* of 1905 (Fig. 71) interpret the continuity and regeneration of the cycle of life rather than the ages of one individual.[189] The last two works were never finished. With the artist's death in 1906 the commission lapsed, and the following year the four panels went into the collection of the Musée du Petit Palais in Paris.

The Mothers is an image of a mother showing her baby to another woman and her adolescent child. *The Fiancées* portrays a young couple holding hands with other

63.

Maternité

1899

Lithograph, 25¼ × 19⅜ in.

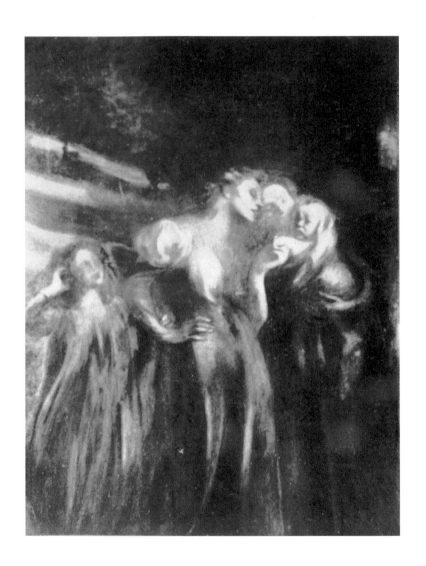

64.

Study for The Mothers

c. 1900

Oil on canvas

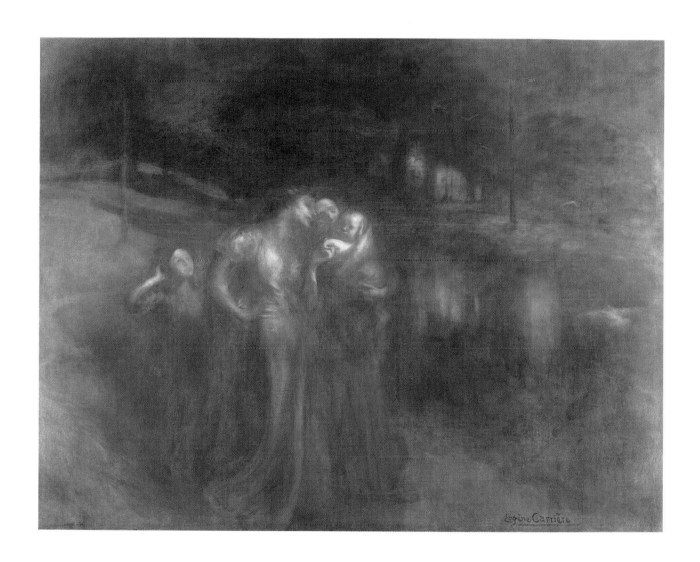

65.

The Mothers

1900

Oil on canvas, 111½ × 142⅞ in.

Musée du Petit Palais, Paris

66.

Study for The Fiancées

1904

Oil on canvas, 18⅛ × 15 in.

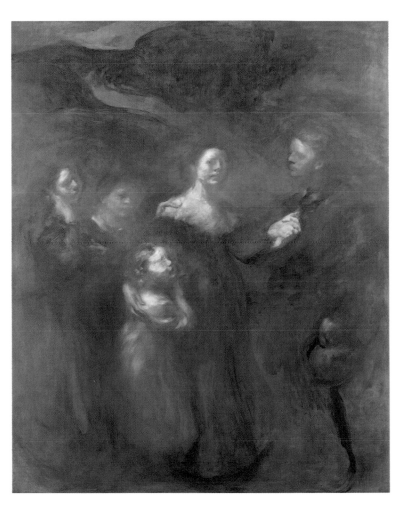

67.

The Fiancées

1904

Oil on canvas, 112 × 91 in.

Musée du Petit Palais, Paris

68.

Study No. 1 for The Nativity

January 1905

Oil on canvas, 19⅞ × 23⅞ in.

69.

Study No. 2 for The Nativity

January 1905

Oil on canvas, 19¼ × 25⅝ in.

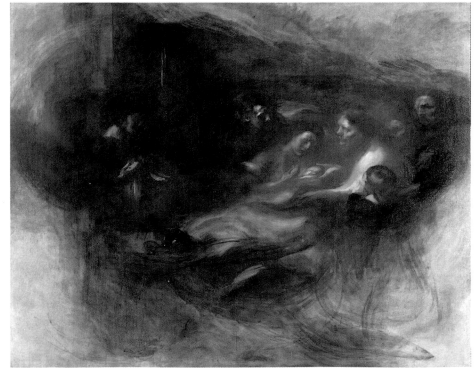

70.

The Nativity

1905

Unfinished

Oil on canvas, 111½ × 140 in.

Musée du Petit Palais, Paris

figures about them. *The Nativity* presents the fruit of the fiancées' emotional and physical union. In the last panel, *The Old People*, Carrière created a central group quite similar to that of *The Mothers*. An old couple hold their grandchild between them, while to the left the young parents embrace. In all four of the panels the environments dissipate near the edges or, conversely, the images progressively coalesce toward their centers.

Carrière rarely did studies, and when he did he considered them complete works on their own terms. His studies, especially those for The Four Ages, which only generally anticipate the final oils, are best thought of as parts of a series. The studies he did for this commission permit an analysis of Carrière's preparatory work as well as of his creative process. The motif of a mother caressing her infant in *The Mothers*, chronologically and thematically the first of the four panels, derives from an earlier lithograph, *Maternité* of 1899 (Fig. 63),[190] the model for which was an earlier oil. Either the lithograph or the oil was in turn the basis for two of the three central figures in the *Study for The Mothers* of about 1900 (Fig. 64). The study is of the figures only (and no other study for the landscape seems to have survived); the expansive environment may have been conceived during the execution of the final oil.

The *Study for The Fiancées* of 1904 (Fig. 66) closely anticipates the poses, pattern of values, and composition of the final oil. But its animation, the undulating rhythms typical of Carrière's late work, is missing in *The Fiancées*, recalling the stylistic distinction between Carrière's noncommissioned works and those he executed for salons and commissions.

The two studies for *The Nativity* (Figs. 68, 69) suggest a more complex evolution of the image. Carrière wrote to Ugo Bernasconi on January 21, 1905, from Mons, Belgium, where he was spending the winter, "I am thinking and I am working, preparing studies for a large work that I am going to execute in the spring." The anonymous editor of Carrière's *Ecrits et lettres choisies* inexplicably identifies this "large work" as *The Nativity*.[191] If this is correct, these two studies may have been done in Mons in January 1905. Carrière's son, Jean-René, says that he and his father talked about *The Nativity*. "I will furnish it with a background," Carrière said,

but there needs to be a supporting element in front. There still remains some compositional work to do with the two figures. The logic of the situation will give it to me. In the large group I tried to let myself be guided by the action of the event. I know very well that what is not useful is detrimental. The subject is complete as it is and nevertheless the canvas needs to be filled, it is difficult!

I had to position my bed almost directly opposite in order to see the whole scene. – Then I still have a lot of room at the side, that needs to be resolved. Here's the subject. They are holding the child up to his mother to see if he will take the breast, this creates a minute of anguish when even the female servant suspends

her work. – There is a halt in activities, for a moment all feelings are shared.[192]
The figures, the poses, and the mood he was describing are those of the final oil, not the studies.

Study No. 1 for The Nativity (Fig. 68) leads to but does not fully anticipate the final oil. The area of vertical striations with small light patches becomes the head, shoulders, and hands of a woman in *The Nativity*, perhaps the servant, who stands with her head bowed as if this was a religious experience. The focal point of both this study and the final panel is to the right, where the father leans over the mother's shoulder to see their newborn child, although the poses of the three figures are slightly different in the study. In the study the corners are left unworked; in the final oil they are light and vaporous, making *The Nativity* look like a vision coalescing in swirling fog. The textures of the paint and the way it was applied also differ in the study and the final work. In the final oil the paint is thicker and more uniformly applied, and there is an absence of texture and visible brushstrokes and an overall effect of subtle transitions of value.

In the first study Carrière was working out the overall scene, the values and rhythmic patterns, and, to some extent, the poses. In the second (Fig. 69) he concentrated on the thematic focal point, the presentation of the breast. Here the mother and the attendant, a light shape at the far right, are posed similarly to the figures in the final version. Only in the final oil, however, is the infant held to the mother's left breast. Neither study entirely anticipates the final version. Carrière may have done other preparatory studies that have been either lost or not yet identified as such, but it is more likely that he worked out many aspects only when he was painting *The Nativity* itself.

The Old People was preceded by two studies: a charcoal sketch, Carrière's initial conception, and an oil study with a number of modifications that appear in the final oil. Séailles records Carrière's comment of December 18, 1904, about what he intended *The Old People* to convey: "Our gestures have not yet faded before our role is taken up again, and the new actor doesn't wait for us to leave the scene; we wish that he would wait at least until he hears the last echoes of our voices so that we might feel the continuity of our being."[193]

Carrière painted *Moonlight* (Fig. 72) sometime during the period he was working on The Four Ages. Comparing it with *Figures in Moonlight* (Fig. 30) is interesting, as the two works almost bracket his career. The somberness and sense of quiet and loneliness of *Figures in Moonlight*, with its muted landscape and two dark huddled figures silhouetted against the mottled blue sky, contrasts strongly with the almost visionary quality of *Moonlight*, which has the force of hallucination. Striations move across the painting, animating the heavens and connecting the figure with the ground, recalling the energized vision of van Gogh's *Starry Night* (1889). *Moonlight* is an expression of dreamlike wonder at the revelation of the spirit's oneness with universal

71.

The Old People

1905

Unfinished

Oil on canvas, 111½ × 90⅞ in.

Musée du Petit Palais, Paris

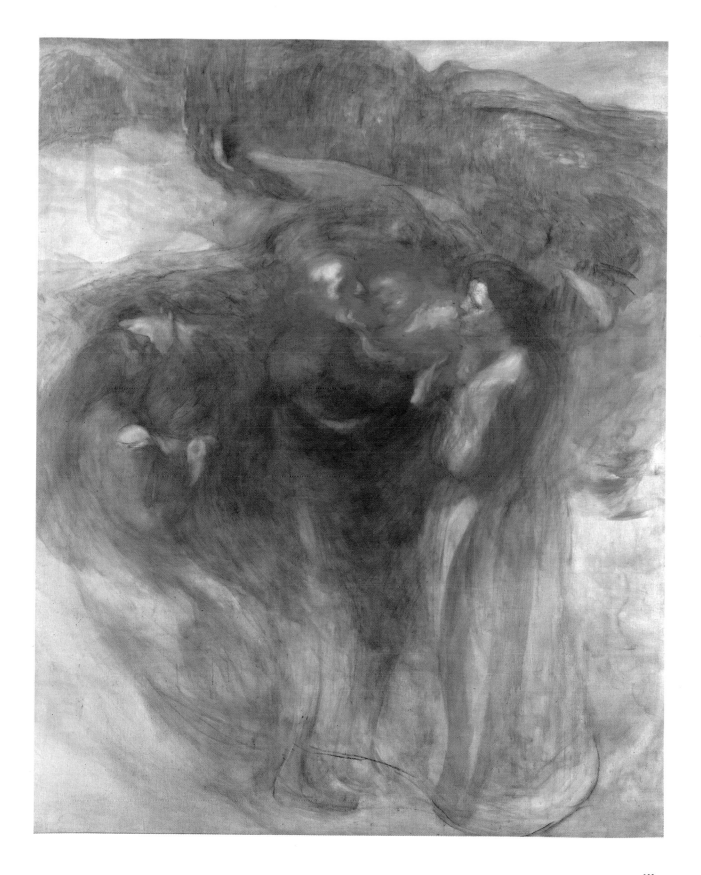

forces. The awestruck, laurel-wreathed figure is not tied to the earth but is swept along the path of the terrestrial plane he projects from, counterbalancing the rising movement of the celestial cloud. And the ethereal and fluid technique, done with little more than glazes, differs markedly from the emphasis on brushstroke, scumblings, and the viscosity of the pigments in Carrière's early work.

Two of Carrière's children, Elise (see Figs. 73, 74) and Jean-René, chose careers in art, Elise as a painter and Jean-René as a sculptor. Carrière trained Elise himself and had his friend Rodin instruct Jean-René.[194] Elise began exhibiting with the Société Nationale des Beaux-Arts in 1901 and showed there regularly until 1933. She also participated in the Salon d'Automne from 1919 until her death in 1934 and in the Salon des Tuileries from 1924 to 1928.[195] In Carrière's *Painting* of about 1899 Elise is shown with palette and brushes in hand studying the features of her younger sister Marguerite. In *Portrait of Elise* of 1905 (Fig. 74),[196] as in most of his works from after the turn of the century, the figure and the fluid rhythms complement each other: the figure gives meaning to the fluid rhythms, which in turn define the figure. Elise's expression could be interpreted as contemplative, even somnambulistic. At a time when his life was endangered and his wife's health was failing, Carrière depicted his firstborn as his artistic heir, the child who symbolically embodied the continuity of his life. One thinks of his remarks on the theme of *The Old People*.

He returned to his refrain in "For the Victims of the Russo-Japanese War," the speech he gave in 1904 at the Trocadero in Paris:

Everywhere the unity of the universe is affirmed. . . . All elements of the world are joined in its equilibrium: All humanity must reunite according to the law of harmony. The history of human evolution would be incomprehensible without this law through which our being senses absolute truth.[197]

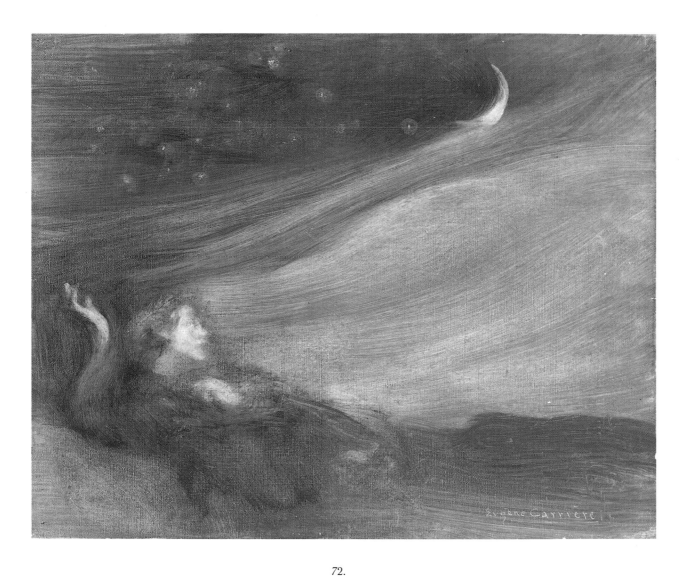

72.

Moonlight

c. 1900–1905

Oil on canvas, 13¼ × 16¼ in.

Cleveland Museum of Art. In Memory of Ralph King.

Gift of Mrs. Ralph King, Ralph T. Woods, Charles G. King,

and Frances King Schafer (46.283)

73.

Portrait of Elise

c. 1901–2

Oil on canvas, 18⅝ × 15½ in.

74. ***Portrait of Elise***, 1905. Oil on canvas, 18⅜ × 15¼ in.

NOTES

For most works cited in the notes a short title is used after the first reference. The following works have been cited in abbreviated form:

Berryer
Anne-Marie Berryer, "Eugène Carrière: Sa vie, son oeuvre, son art, sa philosophie, son enseignement." Ph.D. diss., Université de Bruxelles, 1935.

E. Carrière
Eugène Carrière. *Ecrits et lettres choisies*. Paris: Société du Mercure de France, 1970.

J.-R. Carrière
Jean-René Carrière. *De la vie d'Eugène Carrière*. Toulouse: Edouard Privat, 1966.

Delteil
Loys Delteil. *Le peintre-graveur illustré*. Paris: Chez l'Auteur, 1913. Vol. 8, *Eugène Carrière* (with an unpaginated introduction).

Salon
F.-G. Dumas, ed. Catalogues illustrés of the Salons, 1879–1889. 1879–1881 published by H. Laurette, Paris. 1882–1889 published by L. Baschet, Paris.

Séailles
Gabriel Séailles. *Eugène Carrière: Essai de biographie psychologique*. Paris: Armand Colin, 1911.

1. Quoted in Victor Frisch and Joseph T. Shipley, *Auguste Rodin* (New York: Frederick A. Stokes, 1939), p. 298.
2. Quoted in J.-R. Carrière, p. 173. For the full text of the letter, see note 42 below.
3. Edward Steichen, "The American School," *Photogram* 8, no. 85 (January 1901), p. 6.
4. Isadora Duncan, *My Life* (New York: Liveright, 1927), pp. 91–92.
5. Elie Faure, *Eugène Carrière: Peintre et lithographe* (Paris: H. Floury, 1908), p. 14.
6. Ulrich Thieme and Felix Becker, *Allgemeines Lexikon der Bildenden Künstler von der Antike bis zur Gegenwart*, vol. 6 (Leipzig: E. A. Seemann, 1912), p. 77.
7. Faure, *Peintre et lithographe*, pp. 18–19.
8. Delteil, introd.
9. Letter from Carrière to Séailles, June or July 1897 (Séailles, p. 233): "Je travaille d'après Latour."
10. Ibid.: "Je travaille comme dessinateur à toutes espèces de choses, illustrations, etc. Je fais face ainsi aux exigences de la vie."
11. Paul Ahne, "Notes sur la jeunesse Strasbourgeoise d'Eugène Carrière," in *Trois siècles d'art alsacien, 1648–1948* (Strasbourg: Librairie Istra, 1948), p. 194, mentions that Carrière worked for Clochez but says nothing about the two men meeting earlier in Saint-Quentin. Delteil (introd.) does say the two men met in Saint-Quentin, but the only business arrangement he notes between them is their periodic collaboration between 1883 and 1888. As the Carrière family would have been unable, if not unwilling, to support their son in Paris, and Eugène had only shortly before this completed his apprenticeship, it seems unlikely that he would have left for Paris without assurances of employment.
12. Berryer, p. 13. This story was repeated to me in July 1972 by Ivan Loiseau, Carrière's son-in-law, who then owned the poster.
13. J.-R. Carrière, p. 11. Though he is the only author to cite this meeting of the two men, Jean-René may have been in the unique position to know about it.

14. Delteil, introd. Thieme and Becker (*Lexikon*, vol. 6, p. 77) indicate that Ernest Carrière (1858–1908) was a student of the ceramist Théodore Deck and that at the end of his career he was the director of manufacturing at the Sèvres porcelain factory. Between 1904 and 1908 Ernest exhibited yearly with the Société Nationale des Beaux-Arts. *Dictionnaire critique et documentaire des peintres, sculpteurs, dessinateurs et graveurs*, vol. 2 (Paris: Librairie Grund, 1949), p. 344, says that he also exhibited with the Société des Artistes Français from 1888.

15. J.-R. Carrière, p. 42. In 1874 Carrière received 600 francs; in 1876, 1600; and in 1877, 1000. The scholarship was officially terminated January 15, 1878 (by then he had left the Ecole des Beaux-Arts).

16. Ahne, "Notes sur la jeunesse," p. 194. Berryer catalogues *Portrait of the Artist's Mother* as no. 442. She does not include *Portrait of a Young Girl*.

17. Faure, *Peintre et lithographe*, p. 38. Berryer (p. 16, n. 1) says that one of Carrière's daughters owned a number of Christmas cards her father had done for Marcus Ward.

18. Salon 1879, no. 528; Berryer, no. 11. Letter from Carrière to Séailles, June or July 1897 (Séailles, p. 234): "Mon tableau est mal placé, au-dessous du portrait de la médaille d'honneur de Carolus Duran: une partie de mon tableau dans le velum et l'autre servant de tache sobre au colorist Duran. Personne ne voit mon tableau."

19. For *The Young Mother* and the Avignon prize, see Séailles, p. 234. For the paintings Carrière exhibited at the Salons, see Salon 1880, no. 627, *The Nymph Echo*, and no. 228, *Portrait of M. C. D.*; Salon 1882, no. 429, *Portrait of M. and of Mlle. C. L.*, and no. 490, *Kiss of Innocence*; Salon 1883, no. 458, *Portrait of M. L. Leblanc*; and Salon 1884, no. 445, *Two Friends*, and no. 456, *Marguerite*. Berryer catalogues these paintings as nos. 620, 756, 444, 132, 573, 200, and 198. She indicates that *Two Friends* is often entitled *Child with a Dog*.

20. Roger Marx, *Auguste Rodin, ceramiste* (Paris: Société de Propagation des Livres d'Art, 1907), p. 11. According to Marx, Rodin was absent from the premises during most of the year, with the exception of the months of September and December. Both Frederick Lawton, *The Life and Work of Auguste Rodin* (London: T. Fischer Unwin, 1906), p. 63, and Anne Leslie, *Immortal Peasant* (New York: Prentice-Hall, 1937), p. 108, say that Rodin and Carrière met in 1880.

21. Charles Fournier (Jean Dolent), *Amoureux d'art* (Paris: Alphonse Lemerre, 1888), pp. 191, 233. Dolent also reports that in 1887 Rodin said he had seen some admirable paintings by Carrière.

22. Frisch and Shipley, *Auguste Rodin*, p. 360: "The earliest busts, however, do not display this enveloping charm, a poetic mist that sets a bloom upon the features. Undoubtedly drawn from Carrière's paintings, this softening of the surface, so that the contours seem lost in the stone, appears in Rodin's work with the bust of Mme. Vicuna, in 1884. Exhibited as *The Charmer* at the 1888 Salon, this bust was bought by the state for the Luxembourg Museum; at the International Exposition at Nice, it was awarded the medal for sculpture — Rodin's first."

23. Roger Marx, "Le Salon de 1885," *Le Voltaire*, January 5, 1885, reprinted in J.-R. Carrière, p. 277: "Monsieur Carrière — ceux qui obéissant à un génie intérieur et qui peignent ce qu'ils sentent, peuvent seuls réaliser des oeuvres fortes; témoin M. Carrière, son amour de la nature qui le tourne vers la contemplation de la vie, lui révèle chez les enfants des trésors invisibles pour les regards indifférents. . . . M. Carrière représente la maladie du dernier né, le silence de la douleur plane dans cette chambre que le peintre a remplie de recueillement, il a fait passer dans la tristesse de ses couleurs quelque chose de la terrible angoisse de la mère."

24. Salon 1885, no. 472, *The Sick Child*; no. 473, *The Favorite*. Berryer catalogued the first of these as no. 2. See also Faure, *Peintre et lithographe*, p. 49.

25. Letter from Carrière to Séailles, July 9, 1897 (Séailles, p. 236): "*Le premier voile*, exposé en 1886 — avec un portrait de jeune homme — me fut acheté par l'Etat 1200 francs. Je n'ai su qu'au paiement qui se fit par 150 francs tous les trois et six mois que c'était sur la caisse des secours." In addition to *The First Veil* (Berryer, no. 582), the *Child with a Glass* (Berryer, no. 138) and the *Portrait of Marcel LaCarrière* (Berryer, no. 226) were exhibited.

26. Salon 1887, no. 455. See also Séailles, p. 236.

27. Letter from Carrière to Dolent, May 31, 1886 (E. Carrière, pp. 130–31). See also J.-R. Carrière, pp. 43–44.

28. Jean Dolent was the pen name of Antoine Charles Fournier. He used the name Dolent for all occasions. In the chapter "Salon de 1886" in his *Amoureux d'art* (pp. 203–16), Dolent not only quotes Carrière but comments extensively on his work. In the same chapter (p. 224), the Têtes de Bois is mentioned, perhaps the earliest published reference to it.

29. Carrière mentions having met Séailles in 1888 in a letter to Séailles of July 9, 1897 (Séailles, p. 236). See also Faure, *Peintre et lithographe*, p. 83.

30. See note 99 below.

31. Salon 1889, no. 49, *Intimacy*; no. 495, *Portrait of Mme. P. G.* (Berryer, nos. 456, 10). See also Séailles, p. 237.

32. Berryer, p. 241; Delteil, vol. 12, *Gustave Leheutre*, introd.

33. Claude Roger-Marx, *La gravure originale au XIXe siècle* (Paris: Editions Aimery Somogy, 1962), p. 169, says that this group existed from 1889 to 1900. Carrière is listed as its third president, but no dates are given. No other source, including Delteil, mentions Carrière's association with this group.

34. Delteil, introd. and no. 9.

35. Gustave Geffroy, *L'oeuvre d'Eugène Carrière* (Paris: H. Piazza, 1902), p. 9.

36. John Rewald, *Post-Impressionism: From van Gogh to Gauguin* (Garden City: Museum of Modern Art, 1962), pp. 257, 454. According to Rewald, Vallette's wife, Mme. Rachilde, as well as Henri de Régnier, Vielé-Griffin, Edouard Dujardin, Laurent Tailhade, Maurice Barrès, Jean de Rotonchamp, and the Nabis were also regulars at the Monday night meetings.

37. J.-R. Carrière (p. 165) reprints an undated letter from Charles Morice to Carrière telling him that he would be receiving an invitation to this dinner in about two weeks and that even though one hundred people were expected to attend, the two of them would sit next to one another. Rewald, *Post-Impressionism*, p. 485, lists among the attendees Gauguin, Henri de Régnier, Maurice Barrès, Charles Morice, Octave Mirbeau, Jules Renard, André Fontainas, André Gide, Georges Lecomte, Anatole France, Félix Fénéon, Redon, Signac, and Seurat.

38. "Echos divers et communications," *Mercure de France*, May 1891, p. 318. Carrière's close associations with the literary circles of Paris are attested to by the fact that he and Rodin may have been the only artists who attended the banquet in June 1893 honoring the publication of Victor Hugo's *Tout la lyre*; see Henri Mondor, *Vie de Mallarmé*, vol. 2 (Paris: Librairie Gallimard, 1941), p. 659.

39. Charles Morice, *Paul Gauguin* (Paris: H. Floury, 1920), p. 43.

40. See Rewald, *Post-Impressionism*, p. 457. In *Gauguin Drawings* (New York: Thomas Yoseloff, 1958), Rewald discusses that period and Gauguin's presence in the Café Voltaire: "There he met among others the leaders of the movement, Mallarmé and Moréas, of whom he was to draw portraits; his likeness of Moréas is particularly fraught with symbolic elements. In the company of these men Gauguin discussed at great length the merits of other painters admired by the poets, such as Puvis de Chavannes, whose influence appears in some of Gauguin's Tahitian compositions, Carrière, whom he befriended and even feebly imitated for a short while, but above all Redon, whom he saw frequently and whose mysterious art left a deep impression on him." Gustave Geffroy, who visited Gauguin at Le Pouldu in the summer of 1890, wrote Charles Chassé: "J'ai peu connu Gauguin, m'écrit-il; je l'ai vu chez Carrière à Paris et en Bretagne au Pouldu" (see Charles Chassé, *Gauguin et le Groupe de Pont-Aven* [Paris: H. Floury, 1921], p. 37, n. 2). If Geffroy saw Gauguin at both places in 1890, it would probably have been late in the year that he met him at Carrière's studio. Gauguin was at Le Pouldu from June to November, after which he returned to Paris and started to attend the Monday evening meetings at the Café Voltaire.

41. "Echos divers et communications," *Mercure de France*, March 1891, p. 191.

42. J.-R. Carrière, p. 173: "Mon Cher Carrière, Permettez-moi de vous appeler ainsi. J'ai entendu avec plaisir hier soir, M. Dolent me racontant votre conversation avec lui au sujet de mon portrait. Nos plus grandes satisfactions d'artistes sont celles qui viennent directement de l'art. Et votre estime de votre part, *vous grand artiste*, m'est particulièrement sensible. Qu'importe l'opinion hostile des ignorants et des imbéciles si on est compris d'un délicat. Je répète donc que votre estime m'est doublement la grande récompense de mes travaux. Passant aussi par la bouche d'un homme comme Monsieur Dolent, elle a fait vibrer certaines cordes enfouies intimement au fond de moi. Telle une petite lumière dans un oeil peint par Carrière. Merci, grand merci et tout cordialement à vous."

43. Morice, *Paul Gauguin*, p. 43.

44. Two undated letters from Gauguin help establish a date for the sittings. The first reads: "Mon Cher Carrière, Excusez ma fuite: je vais au plus vite à Copenhague, voir mes enfants. Je serai de retour vers le 12 ou 14 et nous tâcherons de vous poser sans vous déranger. Tout de coeur Paul Gauguin" (My Dear Carrière, Excuse my departure: I am going quickly to Copenhagen to see my children. I will be back around the 12 or 14 and will pose for you at your convenience). J.-R. Carrière (p. 174) dates this letter 1889, which is not possible. H. Rostrup ("Gauguin et le Danemark," *Gazette des beaux-arts* 47 [1956], p. 78) has established from official records that Gauguin arrived in Copenhagen on the

evening of March 7, 1891. Rostrup believes that he stayed less than ten days, citing a letter of March 17 from Madame Gauguin to Johan Rohde in which she says that her husband had returned to Paris several days earlier and that he was staying at 10, rue de la Grande Chaumière. The second letter from Gauguin to Carrière reads: "Mon Cher Carrière, Je suis arrivé aujourd'hui de mon voyage et suis tout à votre disposition pour poser. Veuillez donc m'indiquer le jour et l'heure qui vous dérangeront le moins. Cordialement et à bientôt Paul Gauguin 35, rue Delambre-Paris" (My Dear Carrière, I just returned today from my trip and am at your disposition for posing. Please tell me what day and time will least inconvenience you. Cordially and see you soon). J.-R. Carrière (p. 155) has also dated this letter 1889, but it too was most likely written in 1891.

45. Georges Wildenstein (*Gauguin* [Paris: Les Beaux-Arts, 1964], p. 147, no. 384) dates Gauguin's *Self-Portrait* 1890 and says that the exchange took place in 1891. Wildenstein has noted that there is a partially obscured inscription to Charles Laval at the lower left of the *Self-Portrait*. Laval left for Cairo in 1890 (he died there in 1894; see Charles Chassé, *The Nabis and Their Period*, trans. M. Bullock [New York: Frederick A. Praeger, 1969], p. 122), so the painting would logically date no later than that. Rewald (*Post-Impressionism*, p. 457, dates both Carrière's portrait and Gauguin's self-portrait to 1891, implying that the exchange took place during the same year, before Gauguin's departure, but he later (p. 489, n. 3) says the date for the *Self-Portrait* "is somewhat in doubt; it may have been painted in 1893 after Gauguin's return from Tahiti although it seems more likely that he would have given it to Carrière — to whom it is dedicated — at the time at which the latter did Gauguin's portrait."

46. Charles Morice wrote to Carrière in an undated letter (J.-R. Carrière, p. 164): "Comme vous le savez, Madame Gauguin est ici. Elle voudrait voir, *s'emparer* du portrait de son mari, par vous." R. Field (*Paul Gauguin: The Paintings of the First Voyage to Tahiti* [New York: Garland Publishing, 1977], p. 359, n. 4) comments on an unpublished letter of November 1891 from Gauguin to his wife (discovered by Ursula F. Marks-Vandenbroucke, "Paul Gauguin" [Ph.D. diss., University of Paris, 1956, p. 371]) in which the artist mentioned her having been in Paris during the summer of 1891. Though she may have taken possession of Carrière's portrait of her husband then, it is more likely that she did so in the fall of the following year, when it is known that she was in Paris for the purpose of gathering her husband's works. If so, Morice's letter would also have been written in late fall 1892.

47. Letter from Gauguin to Dolent, in Paul Gauguin, *Lettres de Gauguin à sa femme et à ses amis*, ed. M. Malingue (Paris: Bernard Grasset, 1946), p. 207, no. 116.

48. Madame Rachilde, "Sur Madame La Mort," *La vie moderne* 3 (March 1891), p. 15, first page of unpaginated supplement titled "Théâtre d'art." I am indebted to George L. Mauner of Pennsylvania State University for bringing this design to my attention. He cited it in *The Nabis: Their History and Their Art, 1888–1896* (New York: Garland Publishing, 1978), p. 56.

49. Rewald, *Post-Impressionism*, p. 458. A letter from Gauguin to Madame Rachilde of February 5, 1891 (Gauguin, *Lettres*, p. 209, no. 118) mentions two designs.

50. *Profil de femme* is published in Wildenstein, *Gauguin*, no. 411. René Huyghe ("Initiateur des temps nouveau," in *Collection génies et réalités: Gauguin* [Paris: Hatchette, 1961], p. 275) believes that Carrière showed Gauguin the meaning the arabesque could give to appearances.

51. Pierre Quillard, "Théâtres," *Mercure de France*, July 1891, p. 48; J. Robichez, *Le symbolism au théâtre* (Paris: L'Arche, 1957), p. 492.

52. In his brief catalogue of Carrière's paintings Séailles (p. 265) says that the twelve *ecoinçons* are of 1892. Berryer (no. 584) says they are of 1891. Edmond de Goncourt (Edmond and Jules de Goncourt, *Journal: Mémoires de la vie artistique*, ed. Robert Ricatte [Monaco: Imprimerie Nationale de Monaco, 1956–58], vol. 18, p. 194, entry of May 23, 1892) says that he saw the twelve *ecoinçons* at Carrière's home, the Villa des Arts, in Batignolles. This implies of course that although they were finished, the panels had not yet been installed at the Hôtel de Ville. As it would seem unlikely that Carrière received the commission in 1892 and then executed twelve panels by May, the commission must surely have been awarded and the project started in 1891. Thus Berryer's date would seem to be correct. These works have not been identified beyond their collective title, The Sciences, probably because they are placed so high on a dark wall they go virtually unnoticed by the casual viewer. Because of this and the ban against using a flash attachment, they have not been illustrated in any of the literature on Carrière. One is illustrated in Faure, *Peintre et lithographe*, p. 112, but it must have been photographed in the artist's studio. Berryer (no. 587) lists an oil study for one of the *ecoinçons* which she says is of 1895 and in the collection of Madame Loiseau-Carrière. Jean-Paul Dubray (*Eugène Carrière: Essai critique* [Paris: Marcel Seheur, 1931], p. 85) illustrates an oil study for one of the *ecoinçons* which he says is of about 1895 and in the collection of J.-R. Carrière. Either there are two studies or else sometime

between 1931 and 1936 the study changed hands within the Carrière family. In any case, it seems more logical to assume that the study(ies) in question is(are) of 1891 or 1892, when Carrière was working on the project, and not later.

53. Berryer, no. 14; Société Nationale des Beaux-Arts Salon, 1892, no. 209. Albert Aurier, "Choses d'art," *Mercure de France*, December 1891, pp. 370–71. Albert Aurier, "Choses d'art," *Mercure de France*, December 1891, pp. 370–71, notes that the national collection included works by Manet, Puvis de Chavannes, Rodin, Gustave Moreau, Whistler, Carrière, Gauguin, Odilon Redon, Degas, Cézanne, Claude Monet, Monticelli, van Gogh, Pissarro, Sisley, Renoir, Félicien Rops, Forain, Chéret, Rafaelli, Rodin, Baffier, Henry Cros, and Seurat.

54. Maurice Denis, "Le Salon du Champ-de-Mars: L'Exposition de Renoir," *La revue blanche* 25 (June 1892), reprinted in Maurice Denis, *Théories 1890–1910: Du symbolisme et de Gauguin vers un nouvel ordre classique* (Paris: Rouart and Watelin, 1920), p. 14. Denis was also one of many who perceived a religious spirit in Carrière's work. In 1906 he commented : "C'est par l'émotion religieuse qui l'inspire et qu'elle transmet, que l'oeuvre de Carrière est si admirable" (It is because of the religious emotion that inspires him and is transmitted by his work that Carrière's work is so admirable); see Maurice Denis, "Le renoncement de Carrière: La superstition du talent," *L'ermitage*, June 15, 1906, reprinted in Denis, *Théories*, p. 211.

55. Edmond Potier, "Les Salons de 1892," *Gazette des beaux-arts* 7, ser. 3 (June 1892), p. 450.

56. Paul Gauguin, "Exposition de la Libre Esthétique," *Essais d'art libre*, February–April 1894, p. 32, quoted in M. Roskill, *Van Gogh, Gauguin and French Painting of the 1880's: A Catalogue Raisonné of Key Works* (Ann Arbor: University Microfilms, 1970), pp. 231–32.

57. *Noa Noa* initially appeared in several parts in *La revue blanche*, beginning in October 1897. It was published in its entirety in 1900 by Editions La Plume.

58. M. Guérin, *L'oeuvre gravé de Gauguin* (Paris: H. Floury, 1927), no. 22. The related charcoal sketch is published in Rewald, *Gauguin Drawings*, no. 78.

59. Guérin, *L'oeuvre gravé de Gauguin*, no. 26.

60. "Echos divers et communications," *Mercure de France*, May 1891, p. 96; R. Goldwater, "Puvis de Chavannes," *Art Bulletin* 28 (March 1946), p. 37.

61. J. Meier-Graefe, *Modern Art: Being a Contribution to a New System of Aesthetics*, trans. F. Simmonds and G. Chrystal (New York: Arno Press, 1968), vol. 2, p. 62.

62. Téodor de Wyzewa, "Le Salon de 1894: Peinture," *Gazette des beaux-arts* 11, ser. 3 (June 1894), p. 467.

63. "La peinture et la sculpture aux Salons de 1895," *Gazette des beaux-arts* 13, ser. 3 (June 1895), pp. 11, 28.

64. Judith Cladel, *Rodin*, trans. James Whitall (New York: Harcourt, Brace, 1937), p. 113. Cladel says that this show was put together at the urging of Mathias Morhardt, who was anxious to bring the work and fame of these three artists to his own country. Léon Riotor (*Les arts et les lettres* [Paris: Alphonse Lemerre, 1901], p. 53) says that this exposition took place in January 1896.

65. Orangerie des Tuileries, *Eugène Carrière et le Symbolisme* (Paris: Editions des Musées Nationaux, 1949), p. 32; Henry van de Velde, "Les expositions d'art," *La revue blanche* 10 (1896; Geneva: Slatkine Reprints, 1968), pp. 284–85.

66. Frances Keyzer, "Eugène Carrière," *The Studio* 8 (August 1896), p. 135, reprints an English translation of Carrière's preface. Keyzer believes that this was probably the same show that had been exhibited earlier in Paris at Bing's Salon de l'Art Nouveau.

67. E. Carrière, pp. 11–12:
> Dans le court espace qui sépare la naissance de la mort, l'homme peut à peine faire son choix sur la route à parcourir, et à peine a-t-il pris conscience de lui-même que la menace finale apparaît.
> Dans ce temps si limité, nous avons nos joies, nos douleurs; que du moins elles nous appartiennent, que nos manifestations en soient les témoignages et ne ressemblent qu'à nous-mêmes.
> C'est dans ce désir que je présente mes oeuvres à ceux dont la pensée est proche de la mienne. Je leur dois compte de mes efforts et je les leur soumets.
> Je vois les autres hommes en moi et je me rétrouve en eux, ce qui me passionne leur est cher.
> L'amour des formes extérieures de la nature est le moyen de compréhension que la nature m'impose.
> Je ne sais pas si la réalité se soustrait à l'esprit, un geste étant une volonté visible! Je les ai toujours sentis unis.
> L'émouvante surprise de la nature aux yeux qui s'ouvrent sous l'empire d'une pensée enfin voyante, l'instant et le passé confondus dans nos souvenirs et notre présence . . . tout cela est ma joie et mon inquiétude.

Sa mystérieuse logique s'impose à mon esprit, une sensation résume tant de forces concentrées! Les formes qui ne sont pas par elles-mêmes, mais par leurs multiples rapports, tout, dans un lointain reculé, nous rejoint par de subtils passages; tout est une confidence qui répond à mes aveux et mon travail est de foi et d'admiration.

Que les oeuvres ici présentées un peu témoignent de ce que j'aime tant.

68. Geffroy, *L'oeuvre*, p. 11; Delteil, no. 25.

69. *Maternité* (Delteil, no. 23), in Georges Denoinville, *Sensations d'art* (Paris: E. Gerard, 1896); *Reading* (Delteil, no. 29), in *Etudes de femmes*, pt. 3 (Paris: Lemercier, 1896); *Dreaming* (Delteil, no. 30), in Jean Dolent, *Monstres* (Paris: A Lemerre, 1896).

70. Delteil, no. 35. J.-R. Carrière (pp. 24–25) recounts that he and his father visited Clemenceau at his office shortly after the artist had done the poster.

71. Delteil, no. 40, *The Miner*; no. 41, *The Founder*.

72. E. Carrière, pp. 13–14. The poster is Delteil, no. 39.

73. Geffroy (*L'oeuvre*, p. 11) records that Carrière exhibited *Le Théâtre de Belleville*, *Christ on the Cross*, *Portraits of Mme. Caplain and of Her Little Daughter*, *Portrait of M. Gabriel Séailles*, *Sleep*, *The Study*, *Portrait of Mlle. Ménard-Dorian*, and *Portrait of Paul Verlaine*. The artist also sent five lithographs: the portraits of Edmond de Goncourt, Alphonse Daudet, Paul Verlaine, and August Rodin (Delteil, nos. 25, 16, 26, 33) and a work entitled *Head of a Woman*, which does not appear in Delteil's catalogue. Though Delteil does not mention that it was shown in 1900, the lithograph in question may be his no. 14, *Meditation*, which he notes was titled *Head of a Woman* when it was first published in *L'artiste* in 1893.

74. Berryer, p. 27.

75. E. Carrière, pp. 16–19:

Il faut aller de la nature à l'art et de l'art à la nature. Comment intéresser à l'expression des formes plastiques des êtres qui n'ont pas appris à les comprendre et à les aimer dans la vie?

Quoi de plus justifié dans ce cas que la Pensée de Pascal: "Quelle vanité que la peinture qui pense nous intéresser par la reproduction des choses qui ne nous intéressent point dans la nature."

L'art n'est donc intéressant que lorsqu'il nous parle des choses que nous avons appris à connaître. Ainsi nous émeuvent les images des êtres que nous sont chers. C'est par l'éducation, par l'enseignement des formes objectives, que nous devons préparer l'homme à en voir exprimer la figure et le sens dans l'art. . . .

Pour se reconnaître dans les oeuvres d'art, il est indispensable que nous ayons le sentiment de notre être, et nous l'avons par comparaison. Il faut donc commencer par étudier nos semblables pour les retrouver en nous et nous reconnaître en eux.

Les formes extérieures portent en elles cet enseignement de la logique des apparences des êtres et choses.

Elles développent en nous le sens de l'analyse et le besoin d'harmonie générale que prend des noms si différents, elles nous mettant en garde contre les oeuvres de mensonge et de mode qui sont contraires à la vie. . . .

La visite aux musées doit suivre la fréquentation et l'initiation à la nature. Sans cette préparation les hommes passent devant les oeuvres d'art comme les ignorants devant les savants, pleins de respect, mais avec ennui; ils s'arrêtent à ce qui se trouve à leur misérable portée, s'amusent d'une ignorance fraternelle et droite, aguichés par la ruse flatteuse du courtisan des foules.

76. Carrière's lithographic image was based on his painting *Portrait of Rodin Sculpting* (Berryer, no. 481; now in the Musée Rodin, donated in 1930 by L.-H. Devillez).

77. Delteil, vol. 6, *Rude, Barye, Carpeaux, Rodin*, no. 12.

78. Frisch and Shipley, *Auguste Rodin*, p. 298.

79. Albert Elsen, *Rodin's Gates of Hell* (Minneapolis: University of Minnesota Press, 1960), p. 7. Rodin owned nine paintings by Carrière; he obtained three of them, all inscribed to him, in exchange for three sculptures he gave Carrière in 1897 (see Mathias Morhardt, "Eugène Carrière," *Magazine of Art* 22 [1898], p. 556.

80. The Musée Rodin in Paris alone has seventy-one sculptures that show the influence of Carrière: fifty of marble, nineteen of plaster, and two of bronze. Between 1899 and 1908 nine noted historians and critics commented on the stylisitic similarities between Rodin's and Carrière's work. Maurice Hamel, "Les Salons de 1899," *La revue de Paris* 6 (June 1, 1899), pp. 661–62; Roger Marx, "Auguste Rodin," *La plume* (July 1, 1900), p. 402; Léon d'Agenais, "Un peintre voyant," *Les maîtres artistes* 2 (December 1901), p. 40; Yvanhoë Rambosson," "Eugène Carrière," *Les maîtres artistes* 2 (December 1901), p. 51; Camille Mauclair, "La psychologie du mystère," *Les maîtres artistes* 2 (December 1901), p. 45; idem,

"Auguste Rodin," *Les maîtres artistes* 8 (October 15, 1903), p. 272; idem, *Idées vivantes* (Paris: Librairie de l'Art Ancien et Moderne, 1904), pp. 20–21; idem, *Auguste Rodin: The Man, His Ideas, His Works*, trans. C. Black (London: Duckworth, 1905), pp. 112–13; Charles Morice, "Les Salons de la Nationale et des Français," *Mercure de France*, June 1904, pp. 700–701; Jacques-Emile Blanche, "Notes sur le Salon d'Automne," *Mercure de France*, December 1904, p. 689; Lawton, *Auguste Rodin*, p. 6; Faure, *Peintre et lithographe*, p. 88. More recent opinions, reflecting changes of taste, cite Rodin as Carrière's model. In one of his writings of 1926, Elie Faure (*Histoire de l'art: L'art moderne* [Paris: Livre de Poche, 1967], vol. 2, p. 142) accepted the affinities between the work of Carrière and Rodin but clearly argued that Rodin was the greater of the two and, by implication, that the sculptor influenced the painter. Albert Elsen (*Rodin* [New York: Museum of Modern Art, 1963], p. 138) states that Michelangelo, not Carrière, influenced Rodin. Most other writers on Rodin accept that Carrière had a very limited influence on Rodin's work.

81. Cladel, *Rodin*, pp. 75–76. Auguste Rodin, *L'art: Entretiens réunis par Paul Gsell* (Paris: Bernard Grasset, 1911), pp. 239–40.

82. Robert Descharnes and Jean-François Chabrun, *Auguste Rodin*, trans. Edita Lausanne (New York: Viking Press, 1967), p. 201.

83. Edward Steichen, *A Life in Photography* (New York: Doubleday, 1963), chap. 2, p. 1.

84. Ibid., p. 4.

85. Edward Steichen, "The American School," *Photogram* 8, no. 85 (January 1901), p. 6.

86. For illustrations of these photographs, see Descharnes and Chabrun, *Auguste Rodin*, p. 201.

87. Robert Bantens, *Eugène Carrière: His Work and His Influence* (Ann Arbor: UMI Research Press, 1983), pp. 76–77.

88. Roger Marx, "Les Salons de 1895," *Gazette des beaux-arts* 14, ser. 3 (July 1895), p. 11.

89. Berryer (p. 242) says that Madame Hertz-Eyrolles informed her that when she entered Carrière's studio in 1900 she was the fiftieth student.

90. Alfred Barr, *Matisse: His Art and His Public* (New York: Museum of Modern Art, 1951), pp. 38, 49.

91. Raymond Escholier, *Matisse: A Portrait of the Artist and the Man*, trans. Geraldin and H. M. Colville (New York: Praeger, 1960), p. 42.

92. Quoted in Berryer, p. 242.

93. Félicien Fagus, "Espagnols," *La revue blanche* 29 (September–December 1902), pp. 65–68: "Ils n'ont pas encore leur grand homme, le conquérant qui absorbe tout et tout renouvelle, fait dater tout de lui, qui se façonne un illimité univers. Ils se souviennent avantageusement de Goya, de Zurbarán, d'Herrera, s'aiguisent avec Manet, Monet, Degas, Carrière, nos impressionnistes. Lequel—le moment est mûr—se fera leur Greco? Il est vrai que ce grand initiateur du grand art hibérique n'était point né espagnol; et nécessairement, qui sait? alors . . . Carrière peut-être."

94. "Sur la dance de Mlle. Isadora Duncan"; "Sur l'éducation artistique"; "Gauguin"; "L'art antique"; "Sur l'Ecole de Rome"; "Sur le rôle du prolétariat contre la guerre"; "Constantin Meunier"; "Contre les restaurations"; "Albert Besnard" (E. Carrière, pp. 20–22, 41–44, 45–51, 77–83, 84–85, 89, 90–93, 96–98).

95. Berryer, no. 590; Société Nationale des Beaux-Arts Salon, 1898, no. 244.

96. Orangerie des Tuileries, *Eugène Carrière et le Symbolisme*, p. 32.

97. In a letter to M. d'Estournelles de Constant, November 6, 1903 (E. Carrière, pp. 269–70), Carrière said he was working on the project and hoped to submit it to him soon. The editor of Carrière's letters adds the following note: "Il s'agit du tableau *Le baiser de la paix*, spécialement composé par Carrière à l'occasion de la visite que firent en France des membres du Parliament brittanique, le 25 novembre 1903. Des reproductions de cette oeuvre servirent à commémorer cette visite." Berryer (no. 668) says that *The Kiss of Peace* (or *L'entente cordiale*) was used on the menu cover.

98. Charles Morice's *Eugène Carrière: L'homme et sa pensée, l'artiste et son oeuvre, essai de nomenclature des oeuvres principales* (Paris: Société du Mercure de France) appeared in 1906, after the artist's death.

99. Gabriel Séailles, "Eugène Carrière: L'homme et l'artiste," *Revue de Paris* 3 (1899), pp. 147–92. This was further expanded and published in 1911 as *Eugène Carrière: Essai de biographie psychologique* (Paris: Armand Colin).

100. "Echos," *Mercure de France*, August 1902, pp. 559–60.

101. Letter from Carrière to the president of the Société Nationale, October 7, 1904 (J.-R. Carrière, pp. 90–92).

102. Berryer, no. 493. "Echos," *Mercure de France*, June 15, 1905, p. 639, mentions that Carrière and Renoir were the honorary presidents in 1905.

103. E. Carrière, p. 43. The article is dated October 14, 1903.

104. See Arts Council of Great Britain, *French Symbolist Painters: Moreau, Puvis de Chavannes, Redon and Their Followers* (London: Arts Council of Great Britain, 1972), p. 31, no. 25 (*Grief* or *Mater Dolorosa*), entry by Genevieve Lacambre. See also *The Other Nineteenth Century: Paintings and Sculptures in the Collection of Mr. and Mrs. Joseph M. Tanenbaum*, ed. L. d'Argencourt and D. Druick (Ottawa: The National Gallery of Canada, 1978), p. 70, entry by Robert Bantens.

105. "Echos," *Mercure de France*, January 1905, pp. 160–61.

106. Berryer (no. 25) dates *Intimacy* to 1903. On November 8, 1903, Carrière wrote to Raymond Boneheur (E. Carrière, p. 271): "J'ai besoin de terminer mon tableau que je veux envoyer à Saint-Louis, et je n'ai que juste le temps" (I need to finish the painting that I want to send to Saint Louis and I barely have time). J.-R. Carrière (p. 50) says that this work received a gold medal in Saint Louis. See also Berryer, p. 3.

107. E. Carrière, pp. 101–3:

> Une oeuvre d'art exige le respect de la proportion des volumes et des valeurs, le sens de leur proportion d'intérêt par rapport à l'ensemble.
>
> Pour rendre plus claire cette affirmation, évoquons la figure humaine. Nous nous rendrons aisément compte combien les différentes parties du corps ont des proportions particulières; les unes nous présentent de fortes surfaces, des plans larges et solides; d'autres, plus discrètes, les accompagnent, les font valoir selon leur proportion d'intérêt, et nous donnent ainsi l'expression totale de la vie dans l'harmonie de l'unité.

The lecture was given before a conference chaired by Jean Delvolvé on September 23. The February 15, 1906, issue of *Mercure de France* reprinted Carrière's speech. Berryer (p. 45) has noted the artist's whereabouts at the time: "C'est de Mons aussi, qu'il se rendit à l'Exposition de Liège, et le 23 septembre 1905, au pavillon des Beaux-Arts, il parla en public pour la dernière fois."

108. At the 1905 Salon d'Automne Carrière exhibited five recent paintings: *Portrait of Mlle. L. Breval, Tenderness, Portrait of Elise Secluded, Portrait of Anatole France,* and *Portrait of M. X.* (Berryer, nos. 543, 58, 486, 539, 524; Salon d'Automne catalogue nos. 300bis, 298, 300, 299, 300ter).

109. J.-R. Carrière, p. 38.

110. "Echos," *Mercure de France*, April 15, 1906, pp. 635–36. Roll, d'Estournelles de Constant, and Dujardin-Beaumetz also delivered eulogies.

111. Quoted in Frisch and Shipley, *Auguste Rodin*, p. 305.

112. "Echos," *Mercure de France*, April 15, 1907, p. 782.

113. J.-R. Carrière, p. 49.

114. Orangerie des Tuileries, *Eugène Carrière et le Symbolisme*, p. 32. Berryer (p. 3) notes that the works were shown in a room set aside for the occasion.

115. The best source of information on this show is Arsène Alexandré et al., *Eugène Carrière* (Paris: Bernheim-Jeune, 1906), which is the sale catalogue for the show. For the sales totals, see Jacques Daurelle, "La vente de l'atelier Eugène Carrière," *Mercure de France*, July 1, 1906, pp. 149–51. The highest price received at the sale for a work by Carrière was 10,500 frances for *The Older Sister*. "L'atelier Eugène Carrière," *L'art moderne* 26 (June 10, 1906), p. 185, records that Cézanne's landscape sold for 3,200 francs and Renoir's head of a woman sold for 2,000 francs.

116. "Echos," *Mercure de France*, February 5, 1907, p. 767.

117. "Echos," *Mercure de France*, June 1, 1907, p. 381. Morice spoke on May 26.

118. Orangerie des Tuileries, *Eugène Carrière et le Symbolisme*, p. 32. The show was open from May to July 1907.

119. Ibid.

120. On p. 46, J.-R. Carrière says that the sale at Choublier et Cie. took place December 2–3; on p. 47, however, he notes that the "vente de la succession de Madame Eugène Carrière" took place on February 2, 1923, and then lists the fourteen works represented in the sale but does not mention the dealer. Berryer (p. 3) records this sale as "Exposition précédant la Vente de la Succession de Mme. Carrière, 20 fevrier 1923." From this, one can assume there may have been as many as three separate sales.

121. René Huyghe, "Carrière et la Donation Devillez," *Beaux-arts* (December 1930), p. 3. J. R. Carrière (p. 47) confuses the matter by referring to an "Exposition de la Donation Louis Devillez au Louvre" in 1930 and then noting that forty-six paintings were shown in 1931 at the Orangerie des Tuileries, as if that was a separate show.

122. Museo Nacional de Bellas Artes and Jockey Club, *Catalogo de la Exposicion de las Obras de Eugène Carrière* (Buenos Aires: Amigos del Arte, 1936).

123. Orangerie des Tuileries, *Eugène Carrière et le Symbolisme*, p. 32.

124. Included in this show were sixty-one paintings, twenty-three drawings, and two lithographs, by Carrière, Puvis de Chavannes, Moreau, Renault, Redon, Rodin, Gauguin, van Gogh, Denis, Ranson, Vallotton, Roussel, Bonnard, and others.

125. Berryer, no. 442. Carrière (E. Carrière, pp. 106–7) said about his mother: "Never was a woman more generous, more submissive. She sacrificed herself for her children, in her meager resources she continued to find joy in singing to those around her. How was it possible? Nature created her rich, and society made her poor; she always lived according to her basic nature. It was a magnificent lesson for me and a support all my life, and in my hours of incertitude I return to this cradle and I ask for proof of what I am. I always find the necessary answer there. Man lives his entire existence based on his childhood. How unfortunate that we are so little aware of it! To be overburdened by the cradle!"

126. Letter from Carrière to Séailles, June or July 1897 (Séailles, p. 235). While it seems from this statement that the artist was alone in London, it has always been maintained by Carrière's biographers and his family that his wife accompanied him. Perhaps he meant to imply that during his stay in London his lack of personal and artistic contacts left him quite alone professionally, as had been the case with Turner earlier in the century.

127. "My dear Carrière," Henner wrote, "I regret having missed you this morning, but I would return if I knew I'd find you. Will you be there on Tuesday at 11:00? I don't know if I could come before, but I would very much like to see your paintings. I give you my regards while I wait to hear from you. Mr. Henner" (J.-R. Carrière, p. 255). Having renounced Cabanel and the Ecole, Carrière may have looked to Henner as a master whose work was more compatible with his personal stylistic and thematic tendencies.

128. Berryer, no. 443.

129. Berryer, no. 197. Berryer does not indicate that the painting was shown at the Salon. But as it has the same title and is the only known work of that year, this is probably the Salon piece in question. The two children would be Elise (b. 1878) and Eugène Léon (b. 1881).

130. Berryer, no. 143.

131. This observation was made by a number of writers, among them Gabriel Séailles ("Eugène Carrière," *Revue de Paris* 3 [1899], p. 159), André Mellerio ("D'un tableau de Louvre à Eugène Carrière," *Les maîtres artistes* 2 [December 1901], p. 52), and Gustave Geffroy ("Eugène Carrière," *L'art et les artistes* 3 [May 1906], pp. 66–67).

132. I found this article accidently when a folded sheet from *La tribune médicale* turned up as a bookmark in a book I purchased. Unfortunately, beyond the fact that this article, "La perception des couleurs chez Eugène Carrière," appears on page 7, I have been able to determine nothing about it. An article on the opposite side of this sheet is dated January 7, 1908, this being the latest of the dated articles.

133. Albert Boime, *The Academy and French Painting in the Nineteenth Century* (New Haven: Yale University Press, 1986), p. 76.

134. This painting cannot be related to any other work. It is possible that Carrière frequently did oil sketches much as he did his pencil sketches, simply to capture a moment or an idea.

135. Berryer, no. 45. This painting was acquired by John G. Johnson of Philadelphia directly from the artist.

136. *Verlaine: Oeuvres poétiques complètes*, ed. Y.-G. Le Dantec (Paris: Gallimard, 1962), pp. 236–37: "Pas la Couleur, rien que la nuance! / Oh! la nuance seule fiance / Le rêve au rêve et la flûte au cor!"

137. Stéphane Mallarmé, "Réponse à une enquête," quoted in Jules Huret, *Enquête sur l'évolution littéraire* (Paris: Charpentier, 1891), p. 60: "*Nommer* un objet, c'est supprimer les trois-quarts de la jouissance du poème qui est faite du bonheur de deviner peu à peu; le *suggérer voilà le rêve. C'est le parfait usage* de ce mystère qui constitue le symbole: évoquer petit à petit un object pour montrer un état d'âme, ou, inversement, choisir un objet et en dégager un état d'âme, par une série de déchiffrements."

138. Dolent, *Amoureux d'art*, p. 240.

139. Delteil, no. 2.

140. Berryer, no. 616; Salon 1887, no. 456.

141. Téodor de Wyzewa, "M. Mallarmé," *La vogue* 1 (July 1886), p. 421, reprinted in Guy Michaud, *La doctrine symboliste* (Paris: Nizet, 1947), p. 64: "Tout est symbole, toute molécule est grosse des univers; toute image est le microcosme de la nature entière. Le jeu des nuages dit au poète les révolutions des atomes, les conflits des sociétés, et le choc des passions. Ne sont-ils point, tous les êtres, des créations pareilles de nos âmes, issues des mêmes lois, appelées à la vie par les mêmes motifs?"

142. E. Carrière, pp. 11–12. See note 67 above.
143. Edouard Schuré, *Les grands initiés* (Paris: Perrin, 1889), pp. XVIII–XIX, reprinted in Michaud, *La doctrine symboliste*, pp. 34–35: "L'esprit est la seule réalité. La matière n'est que son expression inférieure, changeante, éphémère, son dynamisme dans l'espace et le temps. — La création est éternelle et continue comme la vie."
144. Quoted in Dolent, *Amoureux d'art*, p. 213.
145. E. Carrière, pp. 321–23.
146. D'Agenais, "Un peintre voyant," p. 34.
147. See Morice, *Eugène Carrière*, pp. 194–95.
148. *Verlaine: Oeuvres*, p. 982.
149. Delteil, no. 18.
150. Delteil, no. 27; Berryer, no. 549.
151. Berryer, no. 586. It was exhibited with the title *Théâtre populaire* at the Société Nationale Salon of 1895.
152. De Goncourt, *Journal*, vol. 17, pp. 63, 158.
153. Berryer, no. 588. Only Séailles (p. 266) dates this work, to 1896. Séailles notes that it was shown at the Exposition Internationale de Bruxelles of 1897 and that it was in the collection of Henri Lerolle.
154. De Goncourt, *Journal*, vol. 19, pp. 211–12.
155. Geffroy (*L'oeuvre*, p. 10) says that at the 1894 Salon Carrière exhibited an oil entitled *Head of a Woman* (not catalogued in Berryer), a study of a figure for *Le Théâtre de Belleville*, which he had been working on and was planning to exhibit the following year.
156. These articles appeared in *La revue indépendante* in November 1886, pp. 37–43; December 1886, pp. 246–53; January 1887, pp. 55–59; February 1887, pp. 192–99; March 1887, pp. 384–91; April 1887, pp. 58–63; May 1887, pp. 244–48; June 1887, pp. 365–71; and July 1887, pp. 55–60. See Haskell M. Block, *Mallarmé and the Symbolist Drama* (Detroit: Wayne State University Press, 1963) for an analysis of these writings.
157. Stéphane Mallarmé, "L'art pour tous," *L'artiste*, September 15, 1862.
158. Letter from Carrière to Madame Séverine, December 1904 (E. Carrière, pp. 310–11).
159. Berryer, no. 627.
160. Téodor Wyzewa, "Le Salon de 1894," *Gazette des beaux-arts* 12, ser. 3 (July 1894), p. 41. The pastel is no. 1285 in the catalogue of the Société Nationale des Beaux-Arts Salon of 1894.
161. Stéphane Mallarmé and James Whistler, *Mallarmé–Whistler correspondance*, ed. C. P. Barbier (Paris: Nizet, 1964), p. 284. The exhibition was held at the Prince's Skating Club of Knightsbridge.
162. Berryer, p. 189, no. 696. Without explanation, Berryer dates this landscape 1897. Dubray, *Essai critique*, ill. opp. p. III, also dates it 1897 without justification. Though no correspondence between them exists, Carrière and Cézanne may have met either in Paris or in the south of France. When Cézanne returned to Paris from Aix in the fall of 1898, he took a studio at 15, rue Hégésippe-Moreau, where Carrière had had a studio since 1888 or 1889; see John Rewald, *The Ordeal of Paul Cézanne* (London: Phoenix House, 1950), p. 179. It is possible that Carrière assisted Cézanne in the arrangements for renting the studio. Victor Frisch (Frisch and Shipley, *Auguste Rodin*, p. 306) recounts an amusing story he heard from Ambroise Vollard when Vollard was Rodin's assistant. One day while Cézanne was painting Vollard's portrait the room suddenly darkened and Cézanne cried out: "Go to it, now! I suppose you've been praying for this, Carrière!"
163. Dolent, *Monstres*, p. 130: "Personne ne connaît les paysages de Carrière, et déjà on les imite."
164. *Exposition d'oeuvres récentes par Eugène Carrière*, Galerie Bernheim-Jeune, April 1–15, 1901. In all, forty-one works were shown.
165. Letter from Carrière to Constantin Meunier, 1898 (E. Carrière, p. 160), written from the Villa Saint-Pierre: "C'est la qui'il m'a falu pour ma femme passer l'hiver." Frequent mentions of Carrière's visits to Pau and Orthez are found in *Francis Jammes et André Gide: Correspondance, 1893–1938*, ed. Robert Mallet (Paris: Librairie Gallimard, 1948), and *Francis Jammes–Arthur Fontaine: Correspondance, 1898–1930*, ed. Jean Labbe (Paris: Librairie Gallimard, 1959). Labbe (p. 217) says in a note concerning a letter of January 1902: "Pour rétablir la santé de sa femme gravement malade, Eugène Carrière vint passer les hivers de 1896, 1898, et 1901 à Pau, où il habita la villa Saint-Pierre, boulevard d'Alsace-Lorraine. Son célèbre *Christ en Croix*, qui lui fut inspiré, dit-on par une fumée entrevue au crépuscule dans les allées du parc du château, sa *Fantine*, executée pour le centenaire de Victor Hugo, ainsi que de nombreux paysages pyrenéens, ont été peints par lui en Béarn."
166. Berryer (p. 31) says that they spent only the seasons of 1896–97 and 1898–99. This is not borne out by

Carrière's own letters, which during the 1901–2 winter season were addressed from Pau.

167. Hans Haug, "Chronologie," in *Eugène Carrière* (Strasbourg: Château des Rohan, 1964), p. 44, is the only source to mention this vacation. Carrière's letter to Madame Ménard-Dorian (see note 168 below) indicates that he was traveling alone and had already been away for two weeks. He implied that at some time soon he was to meet her and Rodin on the Isle of Guernsey. Carrière also mentions this trip in a letter to Jean Dolent of August 1893, written from Saint-Brieuc (E. Carrière, pp. 144–45), and in another to Gabriel Séailles of August 2, 1893, written from "Bretagne" (Séailles, pp. 230–31).

168. Berryer, no. 702. In a letter of August 2, 1893, to Madame Ménard-Dorian (E. Carrière, pp. 142–44), Carrière comments on his trip through Brittany and mentions the roadside "calvaires."

169. E. Carrière, pp. 190–96, 200–202.

170. Carrière's letters of July 3–August 24 (E. Carrière, pp. 287–95) are addressed from Spain.

171. A letter from Carrière to Jean-René, February 17, 1904 (E. Carrière, p. 279), says that they had already visited Rome and were in Florence. In a letter of February (ibid., pp. 279–80) to Maurice Hamel, the artist says they are in Venice. His letter of February 24, 1904, to Jean Delvolvé (ibid., p. 280) was addressed from Milan. Carrière starts a letter of March 3, 1904, to Madame Ménard-Dorian (ibid., p. 281): "Nous voici de retour du voyage en Italie."

172. Berryer, no. 716.

173. Gabriel Séailles, "Eugène Carrière: L'homme et l'artiste," *Revue de Paris* 3 (1899), pp. 162–63. "Dans la nature — me disait un jour Carrière, — les formes sont sympathiques, d'une même famille, les expressions d'une même idée qui peu à peu s'affirme et se précise. Il y a quelque temps, je revenais de Saint-Maur, je regardais par les vitres courier le paysage, et j'admirais l'ondulation des collines, à laquelle se mariait la courbe des feuillages; je me retourne, et en face de moi je vois une femme à la bouche d'un dessin fier et pur, et dans cette bouche comme répète clairement tout ce que je venais de voir et d'admirer. Il y a ainsi une hiérarchie des formes qui s'expliquent l'une l'autre; dans la nature, rien n'est dépaysé, parce que tout est parent, la colline et la plaine, l'arbre, la terre et l'homme; aussi, que dans un beau paysage apparaisse une belle femme, vous ne voyez plus qu'elle, mais en elle vous revoyez tout le reste."

174. Ibid., p. 163.

175. E. Carrière, p. 204:
Nous avons couru un peu les montagnes et les coteaux. Le sens éternel de ces choses, devant lesquelles nous passons si vite, m'est profondement sensible. Il m'est consolant de penser que tout cela est ancien et que nous sommes éphémères passants, et que cela durera encore toujours et que d'autres diront les mêmes choses après nous. J'y trouve aussi grande joie, je ne puis me lasser de regarder, de jouir de mes yeux. Il me passe des fougues de vitalité. Je me sens vivre abondamment, et de coeur je m'unis à cette atmosphère d'ivresse faite de logique sereine: ces belles ondulations de terrains, ces beaux arbres qui brodent de vivantes arabesques sur des ciels mouvants, les jolis tapis souples de verdure profonde et sourde, le bruit des eaux, leur transparence, la rapidité avec laquelle elles s'échappent, se sauvent de nous avec de longues traînées pareilles dans leur dessin, comme nous-mêmes nous venons et disparaissons, laissant les mêmes sillages des disparus aux nouveaux venus.

176. E. Carrière, pp. 27–28: "L'imagination de l'homme s'exalte au contact de la Nature. Visionnaire du réel, il entreprend sa propre découverte. Notre puissance imaginative est dans notre effort incessant pour nous rendre compte de nos rapports avec la Nature, de la place que nous y tenons, de la signification de notre venue parmi la foule des êtres. — Où cette imagination trouverait-elle matière à s'exercer sinon devant les formes infiniment variées du *Squelette*, d'où elle évoque la vie?"

177. Ibid., pp. 28–29: "Le squelette est la preuve matérielle de la continuité des formes, de la logique terrestre. . . . Les vertebres du *Rhinoceros*, en modelé de plantes grasses, sont d'accord avec la terre plantureuse où il règne, chargée de vegétations fortes dont sa masse se nourrit. Il est l'image en mouvement du sol qui le produit."

178. Faure, *Peintre et lithographe*, p. 139.

179. Quoted in ibid., p. 138:
Rien n'est complètement distinct. Partons, pour fixer la pensée, de l'air atmosphérique. Non seulement il entoure et baigne ce que nous appelons les corps, mais il les pénètre, s'y dissout, s'y combine, et eux se mêlent à lui. . . . Il y a non seulement contiguïté, mais continuité de substance entre l'air et ces êtres, car incessamment l'oxygène s'incorpore à leur matière et en ressort, et si l'on suit un petit volume du gaz dans les poumons, dans le sang, dans les organes, on ne peut dire à

aucun moment avec certitudes s'il est encore de l'air ou s'il est déjà du tissu animal. . . .
La vision continue dont nous venons d'esquisser quelques traits est bien loin d'être paradoxale, bien loin même d'être purement intellectuelle et les artistes à l'oeil pénétrant l'ont connu comme les savants. Les peintres ne cherchent-ils pas à rassembler les êtres du paysage et à les amalgamer ensemble dans une gangue d'atmosphère? Et certains même, comme Carrière, dont cette impression tourmente le génie, ne peignent-ils pas de façon que tout tient à tout?

180. D'Agenais, "Un peintre voyant," p. 35.
181. Richard Teller Hirsch, *Eugène Carrière, 1849–1906: Seer of the Real* (Allentown, Pennsylvania: Allentown Art Museum, 1968), introd., p. 9.
182. Jean-Baptiste de Monet de Lamarck, *Philosophie zoologique*, trans. Hugh Elliot (New York: Hafner, 1963).
183. Dubray, *Essai critique*, ill. opp. p. 83, captioned "La Route de Pau, peinture (1899)."
184. Séailles, pp. 45–46: "Pour comprendre le dessin de Carrière, il faut avoir regardé ses albums à couverture grise, manié ces feuilles volantes — lettres de faire part, prospectus — que traînent sur la table de l'atelier, encombrent les tiroirs, s'accumulent dans les cartons, ces "pensers," comme eût dit Watteau, ces pensers du matin et du soir, de toutes les heures de loisirs studieux, où il prépare les oeuvres qui prolongent sa vie dans les images qu'elle crée. Ces innombrables croquis au crayon noir, à la sanguine, sont les notes rapides où se traduit sa passion d'observateur infatigable."
185. Berryer, no. 491; shown at the Salon of the Société Nationale des Beaux-Arts in 1904.
186. Quoted in Frisch and Shipley, *Auguste Rodin*, p. 298.
187. Salon of the Société Nationale des Beaux-Arts, 1901, no. 171.
188. Berryer, no. 476; Salon of the Société Nationale des Beaux-Arts, 1898, no. 243.
189. Berryer, nos. 61–64.
190. Delteil, no. 38.
191. E. Carrière, p. 323, n. 1.
192. Quoted in J.-R. Carrière, p. 133:
Je le meublerai bien avec un fond, mais il faut un appui devant. Dans les deux figures, il reste un effort de composition. La logique du fait me le donnera. J'ai cherché dans le grand groupe à me laisser guider par le geste de la circonstance. — Je sais bien que ce qui est inutile est nuisible. — Le sujet est au complet tel qu'il est et cependant il faut remplir la toile, c'est difficile!
J'ai dû mettre mon lit de face presque, de façon à voir l'ensemble de la scène. — Alors il me reste beaucoup de place à coté, c'est à resoudre. — Voilà le sujet. — On tient l'enfant à la mère pour voir s'il prend le sein, cela fait une minute d'angoisse où même la servante suspend son travail. — Il y a un arrêt dans les occupations, les sentiments sont un moment commun.
193. Quoted in Séailles, p. 201: "Nos gestes ne sont pas encore lassés que notre rôle est déjà repris, et le nouvel acteur n'attend pas que nous quittions la scène; nous voudrions qu'il entende du moins les derniers échos de notre voix, pour que la continuité de notre être nous fut rendue sensible."
194. J.-R. Carrière (p. 27) says that he took lessons from Rodin, and this is confirmed by Victor Frisch, who was Rodin's assistant from 1894 to 1914 (see Frisch and Shipley, *Auguste Rodin*, p. 304).
195. See Thieme and Becker, *Lexikon*, vol. 7, p. 79.
196. Berryer, no. 293.
197. E. Carrière, pp. 74–75: "Partout s'affirme l'unité de l'Univers. . . . Tous les éléments du monde se rejoignent dans son équilibre: toutes les humanités doivent se rejoindre selon la loi de l'harmonie. L'histoire de l'évolution humaine serait incompréhensible sans cette loi dont notre être sent l'absolue vérité."

BIBLIOGRAPHY

Ahne, Paul. "Notes sur la jeunesse Strasbourgeoise d'Eugène Carrière." In *Trois siècles d'art alsacien, 1648–1948*. Strasbourg: Istra, 1948.

Alexandre, Arsène. "La sagesse et les propos d'Eugène Carrière." *Nouvelles litéraires, artistique, et scientifique*, January 24, 1931, p. 5.

————. "L'atelier Eugène Carrière." *L'art moderne* 26 (June 10, 1906), p. 185.

Aurier, G.-Albert. "Eugène Carrière." *Mercure de France*, June 1891, pp. 332–35.

Bantens, Robert J. "Eugène Carrière: His Work and His Influence." Ph.D. diss., Pennsylvania State University, 1975.

————. "Eugène Carrière." In *The Other Nineteenth Century*, ed. L. d'Argencourt and D. Druick, pp. 63–71. Ottawa: National Museums of Canada, 1978.

————. *Eugène Carrière: His Work and His Influence*. Ann Arbor: U.M.I. Research Press, 1983.

————. "Eugène Carrière and Paul Gauguin." *Southeastern College Art Conference Review* 11, no. 4 (1989), pp. 259–68.

Battersby, Martin. "Eugène Carrière." *Art and Artists* 5 (May 1970), pp. 325–31.

Bell, Mrs. Arthur. "Eugène Carrière (1849–1906)." *Art Journal*, November 1906, pp. 16–17.

Bénédite, Léonce. "Eugène Carrière." *Die graphischen Kunst* 21 (1898), pp. 18–20.

————. "L'atelier d'Eugène Carrière." *Revue de l'art ancien et moderne* 37 (January 1920), pp. 48–55.

Berryer, Anne-Marie. "Eugène Carrière: Sa vie, son oeuvre, son art, sa philosophie, son enseignement." Ph.D. diss., University of Brussels, 1935.

Bidou, Henry. "Relativement à Carrière." *Journal des débates*, April 19, 1907, pp. 741–42.

Carrière, Eugène. *Ecrits et lettres choisies*. Paris: Société du Mercure de France, 1907.

Carrière, Jean-René. *De la vie d'Eugène Carrière*. Toulouse: Edouard Privat, 1966.

Colombier, Pierre du. "Un peintre d'origine alsacienne: Eugène Carrière." *La vie en Alsace* 16 (1938), pp. 22–27.

d'Agenais, Léon. "Un peintre voyant." *Les maîtres artistes* 2 (December 1901), pp. 33–40.

Daurelle, Jacques. "Atelier Eugène Carrière." *Mercure de France*, July 1906, pp. 149–51.

Délas, Marcel. "Eugène Carrière." *Les maîtres artistes* 2 (December 1901), pp. 42–43.

Delteil, Loys. *Le peintre-graveur illustré*. Vol. 8, *Eugène Carrière*. Paris: Chez l'Auteur, 1913.

Denoinvilles, Georges. "Carrière." *La plume*, May 1, 1896, pp. 318–19.

Desjardins, Paul. "Eugène Carrière." *Gazette des beaux-arts* 37 (1907), pp. 265–76; 38 (1907), pp. 12–26, 131–46.

Dorchain, Auguste. "L'art de l'âme." *Les maîtres artistes* 2 (December 1901), p. 47.

Dubray, Jean-Paul. *Eugène Carrière: Essai critique*. Paris: Marcel Seheur, 1931.

Fagus, Félicien. "Notes sur Eugène Carrière." *La revue blanche* 30 (January–April 1903), pp. 381–86.

Faure, Elie. *Eugène Carrière: Peintre et lithographe*. Paris: H. Floury, 1908.

Fontainas, André. "Eugène Carrière." *L'art moderne* 25 (January 8, 1905), pp. 9–10.

———. "Eugène Carrière à l'Ecole des Beaux-Arts." *L'art moderne* 26 (May 19, 1907), pp. 156–57.

Fougerat, Emmanuel. "Eugène Carrière 1849–1906." In *Médecines peintures*, n.p. Paris: Innothera, 1954.

Geffroy, Gustave. *L'oeuvre d'Eugène Carrière*. Paris: H. Piazza, 1902.

———. "Eugène Carrière." *L'art et les artistes* 3 (May 1930), pp. 61–69.

Greene, Henry Copley. "Eugène Carrière." *Century Illustrated Monthly Magazine* 74 (October 1907), pp. 409–15.

Hirsch, Richard Teller. "And Where Is the Famous Eugène Carrière?" *Artnews* 67 (October 1968), pp. 52–58.

———. *Eugène Carrière, 1849–1906: Seer of the Real*. Allentown, Pennsylvania: Allentown Art Museum, 1968.

Huyghe, René. "Carrière et la Donation Devillez." *Beaux-arts* (December 1930), pp. 3–4.

Karageorgevitch, Bojidar. "The Latter Works of Eugène Carrière." *Magazine of Art* 26 (1902), pp. 449–53.

Keyzer, Frances. "Eugène Carrière." *The Studio* 8 (August 1896), pp. 135–42.

Le Boutillier, Isabel G. "Eugène Carrière." *The Scrip* 1 (1906), pp. 387–91.

Marx, Roger. "Eugène Carrière." *Image-revue mensuelle littéraire et artistique* 6 (1897), pp. 169–75.

Mather, Frank. "Eugène Carrière." *Scribner's Magazine* 43 (April 1908), pp. 465–75.

Mauclair, Camille. "La psychologie du mystère." *Les maîtres artistes* 2 (December 1901), pp. 43–47.

———. "L'âme d'Eugène Carrière." *L'art décoratif*, May 1902, pp. 58–70.

———. "Idées sur Eugène Carrière." *Art et décoration*, February 1906, pp. 41–51.

Mellerio, André. "D'un tableau du Louvre à Eugène Carrière." *Les maîtres artistes* 2 (December 1901), pp. 51–53.

Morhardt, Mathias. "Eugène Carrière." *Magazine of Art* 22 (1898), pp. 553–58.

Morice, Charles. *Le Christ de Carrière*. Brussels: Editions de la Libre Esthétique, 1899.

———. "Oeuvres d'Eugène Carrière." *Mercure de France*, March 1903, pp. 807–9.

———. *Eugène Carrière: L'homme et sa pensée, l'artist et son oeuvre. Essai de nomenclature des oeuvres principales*. Paris: Société du Mercure de France, 1906.

"Musées et monuments: Deux peintures nouvellement entrées au Louvre." *Revue de l'art ancien et moderne* 43 (1923), p. 390.

Orangerie des Tuileries. *Eugène Carrière et le Symbolisme: Exposition en l'honneur du Centenaire de la naissance d'Eugène Carrière*. Introduction and catalogue by Michel Florisoone, notes by Jean Leymarie. Paris: Editions des Musées Nationaux, 1949.

Oulmont, Charles. *Centenaire d'Eugène Carrière 1849–1949: L'artiste s'adresse aux hommes*. Paris: Editions du Livre Français, 1949.

———. "Sur Eugène Carrière: Documents inédits." *Gazette des beaux-arts* 65 (May–June 1965), pp. 355–58.

Pierquin, Hubert. "Eugène Carrière: La sensibilité et l'expression de son art." *L'art et les artistes* 25 (November 1930), pp. 37–43.

Rambosson, Yvanhoë. "Eugène Carrière." *Les maîtres artistes* 2 (December 1901), p. 51.

———. "Eugène Carrière et ses écrits." *L'art décoratif* 9 (September 1907), pp. 81–93.

Remacle, Adrien. "Critique d'art: Eugène Carrière." *La plume*, October 15, 1891, pp. 357–58.

Roberts, Mary Fanton. "Carrière, the Mystic." *The Touchstone* 5 (August 1919), pp. 384–87, 413.

"Le Salon de la Libre Esthétique: Eugène Carrière." *L'art moderne*, March 1, 1896, pp. 65–67.

Séailles, Gabriel. "Eugène Carrière: L'homme et l'artiste." *Revue de Paris* 3 (1899), pp. 147–92.

———. *Eugène Carrière: L'homme et l'artiste*. Paris: Edouard Pelletan, 1901.

———. "L'individualisme dans la famille." *Les maîtres artistes* 2 (December 1901), pp. 53–55.

———. *Eugène Carrière: Essai de biographie psychologique*. Paris: Armand Colin, 1911.

PUBLIC COLLECTIONS

ARGENTINA

Museo Nacional de Bellas Artes, Buenos Aires

BELGIUM

Museum of Fine Arts, Ghent

CANADA

National Gallery of Canada, Ottawa, Ontario

Art Gallery of Ontario, Toronto, Ontario

FRANCE

Musée du Louvre, Paris

Musée d'Orsay, Paris

Palais des Beaux-Arts de la Ville de Paris, Musée du Petit Palais, Paris

Musée Rodin, Paris

Musée de Pontoise et du Vexin, Pontoise

Musée Saint-Denis, Reims

Musée d'Art Moderne de Strasbourg, Strasbourg

GERMANY

Staatilche Kunstsammlungen Dresden, Dresden

GREAT BRITAIN

Fitzwilliam Museum, Cambridge

National Museum of Wales, Cardiff

Tate Gallery, London

UNITED STATES

Los Angeles County Museum of Art, Los Angeles, California

M.H. de Young Memorial Museum, San Francisco, California

Wadsworth Atheneum, Hartford, Connecticut

Yale University Art Gallery, New Haven, Connecticut

National Gallery of Art, Washington, District of Columbia

High Museum of Art, Atlanta, Georgia

Art Institute of Chicago, Chicago, Illinois

Museum of Fine Arts, Boston, Massachusetts

Harvard University Fogg Art Museum, Cambridge, Massachusetts

Detroit Institute of Arts, Detroit, Michigan

Minneapolis Museum of Arts, Minneapolis, Minnesota

Frick Collection, New York, New York

Metropolitan Museum of Art, New York, New York

Museum of Modern Art, New York, New York

Akron Art Museum, Akron, Ohio

Cleveland Museum of Art, Cleveland, Ohio

Allentown Art Museum, Allentown, Pennsylvania

Philadelphia Museum of Art, Philadelphia, Pennsylvania

Rhode Island School of Design, Museum of Art, Providence, Rhode Island

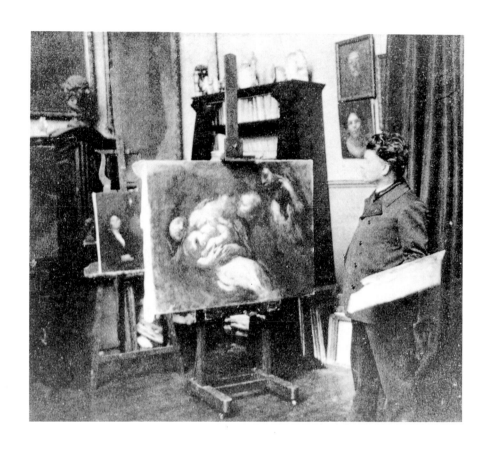

Carrière working on *The Evening Kiss* in his studio at the Villa des Arts, Paris, 1901